THE PLEASURE OF PAINTING
Three Mediums · oil · watercolor · acrylic

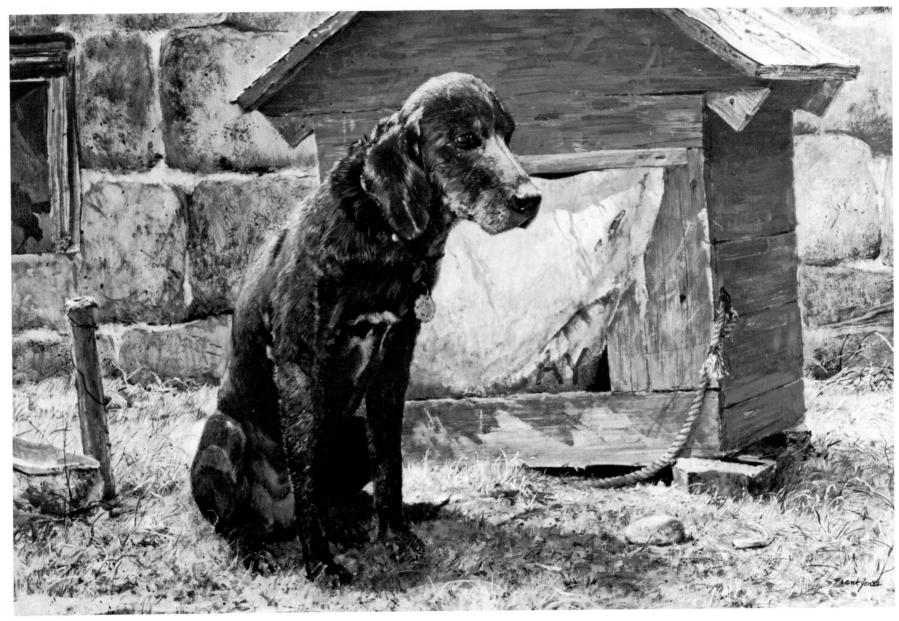

OL' GEORGE
Acrylic, 24 x 36 inches
Owned by Mr. and Mrs. Frank Dupree

2

THE PLEASURE OF PAINTING

Three Mediums • oil • watercolor • acrylic

by Franklin Jones

PUBLISHED BY NORTH LIGHT PUBLISHERS / WESTPORT, CONN.

DISTRIBUTED BY WATSON-GUPTILL PUBLICATIONS / NEW YORK

Published by NORTH LIGHT PUBLISHERS, a division of
FLETCHER ART SERVICES, INC., 37 Franklin Street,
Westport, Conn. 06880.

Distributed by WATSON-GUPTILL PUBLICATIONS, a
division of BILLBOARD PUBLICATIONS, Inc.,
1 Astor Plaza, N.Y.C., N.Y. 10036.

Manufactured in U.S.A.
First Printing 1975

Library of Congress Cataloging in Publication Data

Jones, Franklin, 1921-
 The pleasure of painting.

 1. Painting — Technique. I. Title.
ND1500.J6 751.4 75-6198

Library of Congress Catalog Card Number 75-6198
ISBN 0-89134-001-7 & 0-8230-4036-4
Edited by Walt Reed
Designed by Franklin Jones
Composed in ten point Palatino by John W. Shields, Inc.
Printed and bound by Kingsport Press

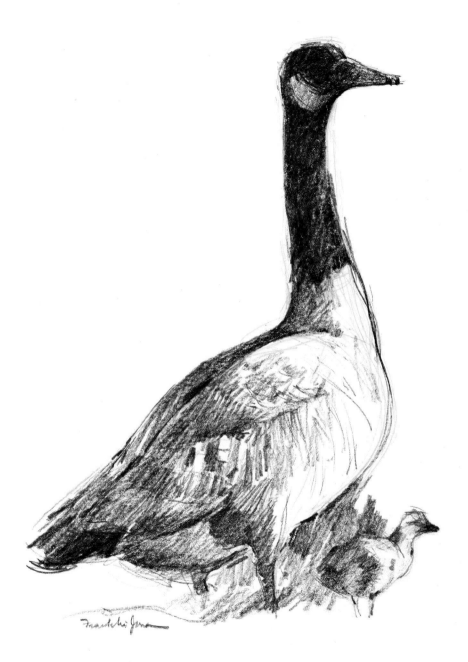

This book is dedicated to Harold L. Moody, whose words of wisdom and encouragement got me started and have stayed with me these past thirty-five years.

Franklin Jones

Contents

Welcome to the studio

The pleasure of painting, for me, is two-fold . . . in the doing and in the sharing. So, through the intimacy of these pages, I'd like to invite you into my studio to spend some time looking at paintings and discussing the three mediums: oil, watercolor and acrylic. The conversation will be one sided, to be sure, but don't hesitate to express your opinion . . . in your own silent way. If you are like me, conversation isn't nearly as vital as the chance to just look; to get up close to a painting and see how a passage was handled; to stand back and see how that passage fits into the whole; to peek at those sketches and studies that lie discarded on the studio floor.

I thought it might be interesting to begin with a broad discussion of the visual and physical characteristics of each medium, and then I'll show you my own approach and the various techniques employed.

Fortunately you've chosen a most delightful day for your visit. It's a warm morning, and the sliding glass door of the studio is wide open to a gentle breeze and the sound of a half-dozen song birds. Although I much prefer painting out-of-doors, my 16 x 21 foot studio is a blessing on those days when that's not possible. Not that one needs this much room to paint, but a spacious work area helps a bit to overcome my resentment of being confined.

Painting out-of-doors, particularly if you're all alone, is something special. I consider it a most rewarding experience. The intimacy with ever-changing sights and sounds, the delight in being

sole surveilant of a meadow knee-deep in mustard blossom, the sense of wonder in discovering a patch of sunlit fern deep in the woods are all more poignant when absorbed by the hour rather than for a few seconds. In such quiet moments, when involved with paint and brush, I have enjoyed the presence of a bushy-tailed fox moving about, just a few feet away, unmindful of my existence.

Sitting on a hillside overlooking a Vermont village I listen to the far away chorus of children playing at recess . . . the crystal tones of the school bell calls them back inside, and only the whir of grasshopper wings breaks the silence of the afternoon stillness.

As I sit contentedly wielding a brush, alone in a clearing where the power lines cut a swath through the woods, I've filled my lungs with the fragrance of blueberries and sweet fern. Each painting session yields a lasting impression that leads to an inner contentment and a joy in living.

The painting, itself, is an adventure in discovery. There is personal delight in achieving a passage of color that unexpectedly brings the painting to life, seeing my inner impressions visually take form. Hopefully others will find the same excitement in my efforts. For the moment I'm filled with a sense of accomplishment in being able to transpose the intricate variations of nature into simple passages of color that express form and distance, sunlight and shadow.

My expounding of the special pleasures of painting for those who have the opportunity to get away to the country should in no way imply that this is a necessity for the landscape artist. For others, the city or town may be equally exciting and offers a lifetime of subjects for the brush. The important thing is to be interested in the world around you . . . to open your eyes, to see something new in that which you previously took for granted. It's not what you paint, but how you paint it that counts.

Whatever the limits of your own painting trips, even though they be no further than your own backyard, you can find delight in rediscovery of sights, sounds and smells. And whatever the limits of your painting skill, you will discover great pleasure in expressing your inner feelings with paint and brush.

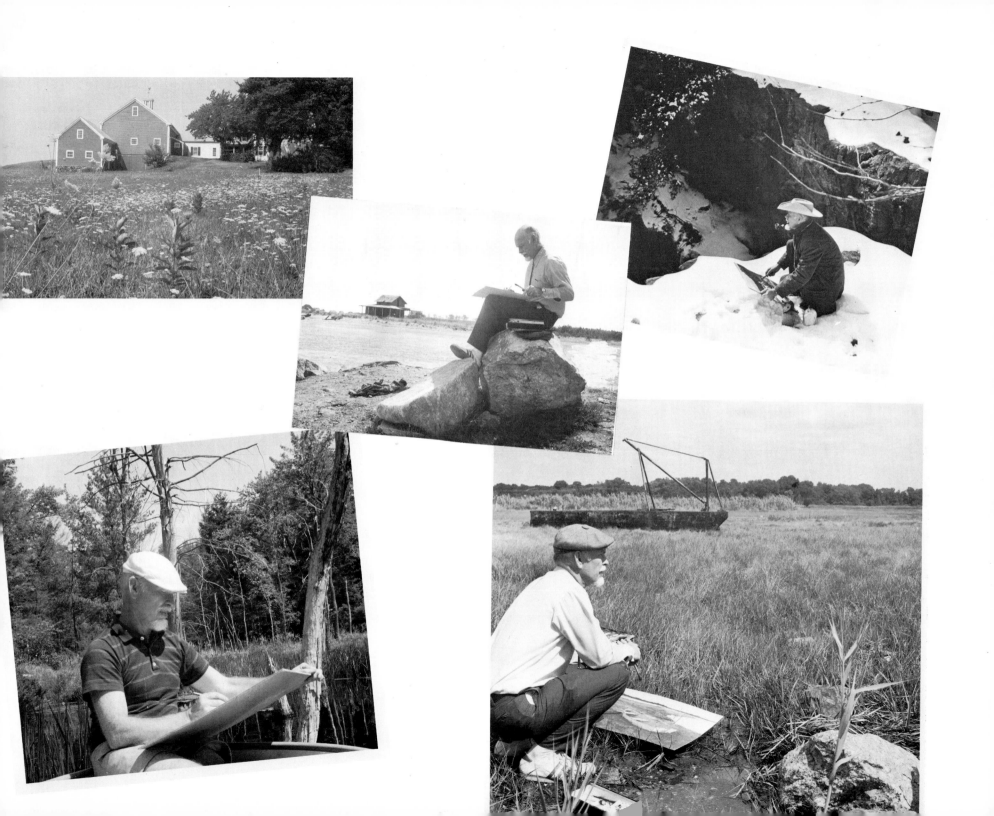

Section 1

Here to there and back again

One of my interests in writing this book is, hopefully, to entice the reader to try all three mediums. Too often people tell me they've tried only one . . . the others look too difficult. Such self-inflicted limitations may be depriving them of much satisfaction. The very medium they shy away from might be the one they would find most successful.

If you've never painted at all, but are just putting your toe in the water so to speak, I hope you'll find this material inspirational enough to make you take the plunge. This book is not intended so much as a technical manual, but to arouse your awareness of those things which lie waiting to be "discovered" as you explore the mediums. It's more important to want to know than to simply gather facts. Once your emotions have been aroused, you'll acquire knowledge as one gathers berries . . . in countless dribbles that, surprisingly, soon overflow the pail.

Basically a person should use the medium that allows him to convey his personal impressions with the greatest ease. In many instances one medium satisfies this need. Others find that two, occasionally all three, are equally comfortable. In that case the choice is optional, depending either on the way the artist wishes to interpret the subject or his personal attitude at the moment. In my own case, for example, I may work with watercolor as a relaxation from the more exacting discipline of my acrylic approach.

The important thing is to be able to concentrate on the creative aspects of a painting. Technique and the medium are, after all, only the means to an end. The great illustrator and teacher, Howard

Pyle, put it this way, "Learning of technique is only a dead husk in which must be enclosed the spirit and life of creative impulse."

As a means to the creative impression, though, learn what the mediums have to offer. Experiment with one for a time, then work with another, and the third. Come back to the first and you'll discover relationships between all three that expand your use of each. Here to there and back again can be an education in the materials of the artist and endless hours in the pleasures of painting.

What are the differences between oil, watercolor and acrylic paints? From a technical standpoint they differ in the vehicles in which the colored pigments are ground and which serve to bind them to the painting surfaces. Basically the color pigment is the same in each medium.

Oil paints are ground in a slow drying oil, such as linseed. Because the oil dries slowly, the artist can work quite leisurely, sometimes for a matter of days, before the paint dries. To thin these paints, when desired, we add more oil or a paint thinner (generally turpentine).

Watercolor pigments contain "gum arabic" which is soluble in water. Therefore, water is the means the artist uses for thinning this paint. Water evaporates quite rapidly, so the painting dries within minutes. While the binder does hold the pigment to the painting surface, it isn't waterproof.

The binder used for acrylic paints is a little more complex. Without getting too technical, it's made up of particles of plastic suspended in water. While in a liquid or buttery state the paint may be thinned with additional water or an emulsion of the acrylic particles. On exposure to the air, the water evaporates and the particles bond together, forming a film of plastic in which the colored pigment is imbedded. Once it has dried, the paint is waterproof. Again, as with watercolor, the paint dries in minutes, or within the hour, depending on the amount used.

As a result of these different binders, the three mediums are applied in different ways, and in some instances, on different surfaces and with different tools. For example, watercolor adheres best to a paper with a porous surface, and once the water has

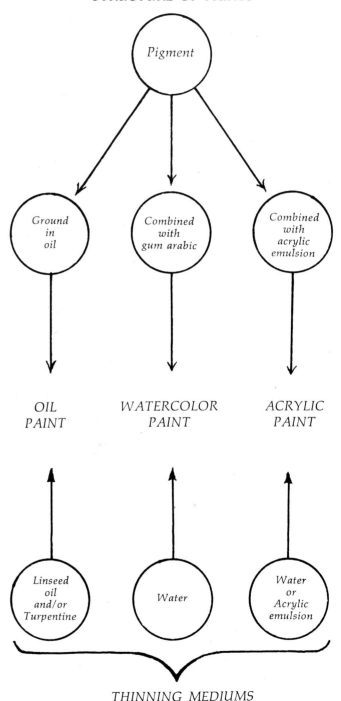

STRUCTURE OF PAINTS

Pigment

Ground in oil

Combined with gum arabic

Combined with acrylic emulsion

OIL PAINT

WATERCOLOR PAINT

ACRYLIC PAINT

Linseed oil and/or Turpentine

Water

Water or Acrylic emulsion

THINNING MEDIUMS

evaporated, the paper itself is unaffected. Oil paints, on the other hand, would stain the paper and eventually cause it to become brittle and easily damaged; therefore oils are generally applied to canvas or other more stable support. Traditionally, then, permanence has been an important consideration, as well as the ease with which the medium may be used. If permanence is not a consideration, then one may paint on almost any surface with any of the mediums. However, I shall refer to the traditional use of materials, for who knows when you will produce a work of art worthy of longevity?

While the difference in the visual appearance of a watercolor and an oil painting is usually quite apparent — one with transparent color on paper; the other with opaque paint on canvas — an acrylic may look like either, depending on how it's used. It may even look like a fourth medium called egg tempera. This might imply that acrylic would replace the other mediums and so simplify the artists' choice of materials. I don't believe so, at least not for everyone. Even though the results may appear similar, acrylic responds differently in its application. And it's the behavior of the paint in the artist's hand, as well as the visual effects, that determines which might be most satisfactory to use. To consider it as a substitute by those who have been using oils and watercolors may lead to a personal disappointment. I say this because I've known a number of artists, including myself, who nearly gave up when it didn't behave exactly like the others. Only when we recognized and took advantage of its particular characteristics did we appreciate and enjoy this medium.

On the pages that follow I'll try to point out the differences and similarities of all three paints, both in their application and visual appearance. Keep in mind that their latitude is much greater than I will show, for this book is limited to my own exploration of their potential. I'll leave further experimentation to you, for each person injects his own personal handwriting, discovers his own unique methods and techniques for expressing his artistic views. That's one of the delightful qualities of art. No two people paint in exactly the same way, even those of similar schools.

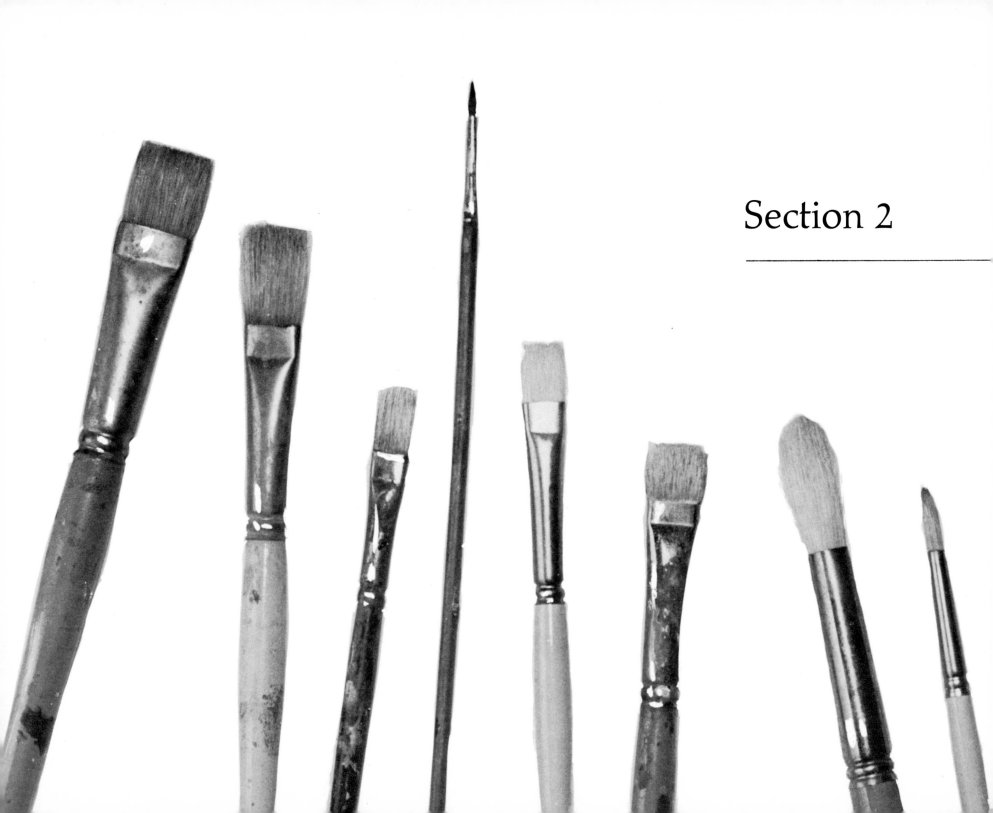

Oil painting

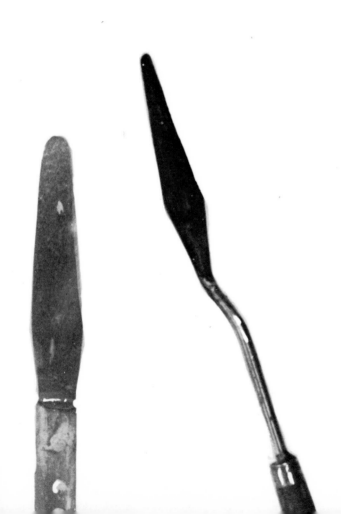

While some artists like to work on a wood panel or other rigid surface, I consider the traditional canvas as the best surface for oil paints. Canvas, stretched taut over a wooden frame, has a resiliency that many prefer to a firm surface. Some artists buy canvas by the yard or roll and stretch it themselves, while others like the convenience of buying it already stretched.

The assorted brushes shown actual size here are those I usually work with. These are made of hog bristle, except for the smallest size extending above the others in the photograph. This latter is a round sable, used for very fine lines. I seldom use the larger sable brushes for landscape painting. The flat-shaped bristle brushes come in two lengths; the longer are called "flats" and the shorter are called "brights." The latter are not quite as flexible.

The size brush to use for any given area is a personal choice. The only advice I can offer is to work with the largest size that will comfortably produce the type of brushwork you desire. A brush that's too small will not only inhibit your techniques but will just slow you down. *Don't use a spoon when the job requires a shovel.*

The tool to the left on this page is a *palette knife,* used to mix colors on the palette or to scrape wet paint from palette or canvas. To the right of it is a painting knife, used to apply paint to the canvas. Painting knives come in a variety of shapes and sizes, usually differing from the palette knife in that the blades are offset from the handles, providing a greater degree of control than the straight blade and handle of the palette knife. The blade of the painting knife is usually more flexible as well, and for this reason is not as rugged.

17

Oil paints are squeezed out onto a palette in quantities suitable for a day's work. Palettes are generally of wood, but any non-porous material may be used. For studio use, plate glass makes a fine surface, easily cleaned with a razor blade even when paint mixtures have dried. Some prefer to hold the palette while working, especially out-of-doors, and most are made with a thumb hole on one edge to facilitate this. Disposable, tear-off paper palettes are also available, but I find a firmer surface is more pleasing. In each case, the piles of paint are spaced around the outer edge of the palette and color mixing is done in the center.

Incidentally, the piles of paint may be left for days. A dry outer skin will form on certain colors, but this can be peeled away to expose the softer core. The mixing area in the center of the palette should be cleaned after each session.

Painting "medium" is used to thin the paints to whatever consistency you like. I should mention here that the word *medium* denotes both the means of artistic expression, i.e., oil, watercolor, pencil, etc., and the liquid used for thinning the paint. To avoid any confusion in this text, I shall place quotation marks around the word *medium* when referring to the liquid for thinning.

A suitable "medium" for oil painting is a combination of linseed oil and turpentine. In addition, you might add a drop of cobalt drier if you wish to hasten the drying of the paints a bit. It's advisable to add some "medium" to every paint mixture; otherwise some colors will take eons to dry. The usual procedure is to dip the brush into the cup of "medium" and stir it into the color you're preparing on the palette.

Turpentine alone is frequently used as a thinning agent during the first stages of laying in the painting or for toning the canvas. But once the paint is applied in any thickness the combination of oil and turpentine should be used, for turpentine alone will weaken the binding quality of the paint. Turpentine, or some other paint thinner, is also used to rinse the brushes during the painting session or at the end of the session.

There are dozens of different colors available for the artist, many of them created for convenience rather than a real necessity or because the intensity (brightness) cannot be achieved by inter-

The dried skin on the surface of a pile of oil paint can be lifted away with a palette knife to expose the soft pigment underneath.

mixing other colors. For purposes of simplifying our discussion let's consider that most of the colors such a yellow ochre, thio violet, Hooker's green, burnt umber, etc., are all modifications of the three primary colors — red, yellow and blue. In fact, for the beginner who has never done any painting, it would be well to start with just these three plus white. I prefer Alizarin crimson, cadmium yellow pale, phthalosyanine blue (in Grumbacher paints it's known as Thalo blue; Winsor and Newton refer to it as Winsor blue), and titanium white, which is usually put up in a larger tube because it's used more than other colors.

The principle of color mixing with the three primaries is as follows: Combining any two in the proper proportions will produce a secondary color — red and blue produce purple; red and yellow produce orange; blue and yellow produce green. A small amount of one primary in a larger amount of another will produce the intermediates: red-orange, yellow-orange, yellow-green, etc.

Combining all three primaries in varying proportions can produce grays, browns, near black and darker or less intense mixtures of the primary and secondary colors. A bit of red and blue, for example, added to yellow can produce a darker, less intense version of yellow. This will, of course, change the color quality of the yellow, but this follows the scheme of color in nature: A bright yellow flower seen in deep shade is different in color than when viewed in sunlight.

Combining all three primaries is similar to combining complementary colors, the latter procedure being used when you expand your range of tube colors. Complementary colors are those on the opposite side of the color wheel. In this case you would add purple to the yellow, equivalent to the red and blue, to produce a darker, less intense yellow.

When working with opaque paints such as oils, you can lighten any of the forementioned colors by adding white. In this regard I should point out that too much white produces a very pastel shade. If you want a more intense color try to lighten the mixture with another light color in addition to the white. A green or red mixture, for instance, may be lightened to some degree by the addition of yellow.

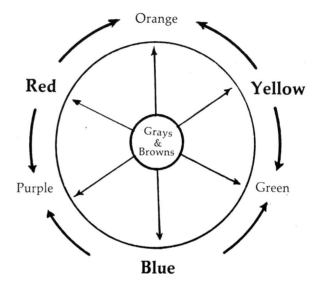

Red, yellow and blue = primary colors

Orange, green and purple = secondary colors

Grays and browns = mixtures of opposite (complementary) colors.

A word of advice: it takes but the tiniest bit of a color to change a mixture. Most color mixing problems are the result of not realizing how little is required. If at first it isn't enough, you can always add more . . . a speck at a time.

In preparation for a painting, the subject may be drawn directly on the white surface with charcoal or with a single oil color. The charcoal sketch is then sprayed with fixative before proceeding, to prevent it from being picked up by the paint.

Some artists prefer to tone the white surface with a thin wash of oil color before making the drawing. They find this darker tone makes it easier to judge color relationships in the early stages of painting. Also, if the person works in a manner that may leave bits of canvas showing in the final painting, the toned surface is more pleasing than stark white. This toning is usually done with a single color, such as umber or sienna, which has been greatly thinned with turpentine. It may be brushed on or, as illustrated here, it may be wiped on with a cloth. The drawing is then done with a brush and a single color.

Although each artist applies paint in a different manner or style, the procedure from bare canvas to finished art is fundamentally the same. *The darker tones are applied first, using relatively thin paint. As the work progresses, paint is applied more heavily with increasingly lighter colors.* Not to mislead you by the brevity of this description, keep in mind that it refers to the development in a broad sense, for it is invariably necessary to work back and forth between light and dark areas to make adjustments. Only a most accomplished artist could put down all the proper tones and strokes the first try.

The painting on the facing page illustrates the various stages of development. The procedure might be compared to building a house. You establish the framework with the drawing. Then you sheath the forms with the darker, thin undertones. Over this goes the thicker, lighter passages for the exterior finish. Finally, the subtle details are added as decorative trim. The strength of the painting lies in the major construction — not in the final trim. To state it more simply: *don't try to hang the wallpaper before you've put up good sound walls.*

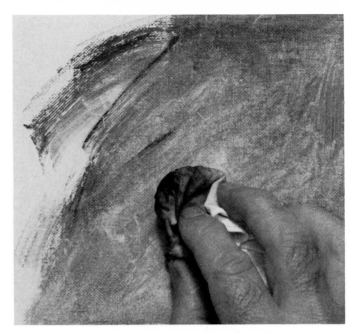

1. *Toning the surface with a rag dipped in oil paint, liberally thinned with turpentine.*

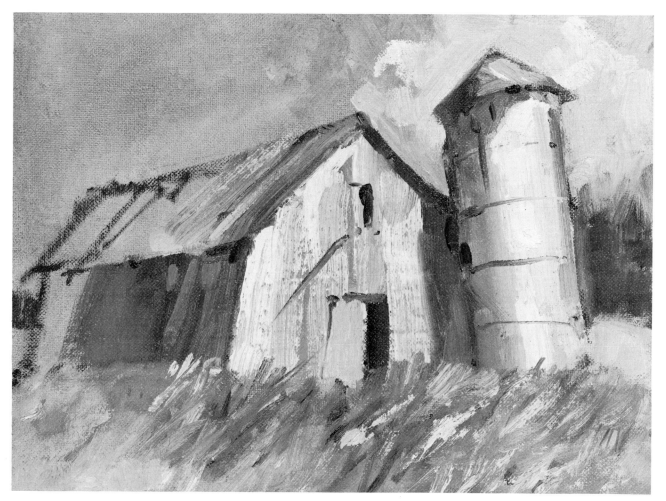

2. The subject is drawn on the toned surface with a brush and burnt umber.

3. The major dark areas of the painting are laid in with thin paint.

4. Next come the middle tones using relatively thicker paint.

5. The lightest areas generally contain the thickest layer of paint.

6. Details and subtle refinements are developed in the latter stages.

The application of oils may vary from smooth, relatively thin layers of paint to thick raised chunks of color, boldly laid on the canvas. The choice is up to the individual. Since it takes some degree of courage or experience to work with thick impasto, many beginners choose the more delicate approach This is to be expected. But if the progressive layers of paint are too thin it will be difficult to make the adjustments that are inevitable. They should be sufficiently thick to hide the underpainting. And there should be enough paint on the brush so it can be applied to the canvas without picking up the wet undercolor. This means mixing sufficient paint each time so the brush can be kept well loaded.

The examples on these two pages represent three methods of working. Experience will determine which is the more suitable direction for you. The still life on the left was done with bristle brushes and the paint was laid on very thickly for the middle and light tones. The effect of one tone blending into another was achieved mostly by value changes rather than by any deliberate brushing of edges.

The still life in the middle, on the other hand, contains a great deal of delicate brushing to blend the tones. The thick and thin variations are barely perceptible. In this case the entire painting was done with sable brushes, resulting in a smoother paint surface.

The third still life represents the approach that I prefer. It was done with bristle brushes using moderately thick paint in the middle and light areas. The effect of blended edges is the result of close values and one brush stroke dragging through another so the two tones slightly intermix.

Note the directness of the brush work used to describe the form on the upper part of the apple. A single "S-shaped" stroke established the light tone around the depression, followed by a short wider stroke at right angles to this to show the curve of the apple's surface. Then a single dark stroke formed the depression itself. It's almost as though the brush were sculpting the form out of clay. The arrows on the diagram illustrate the areas to which I'm referring.

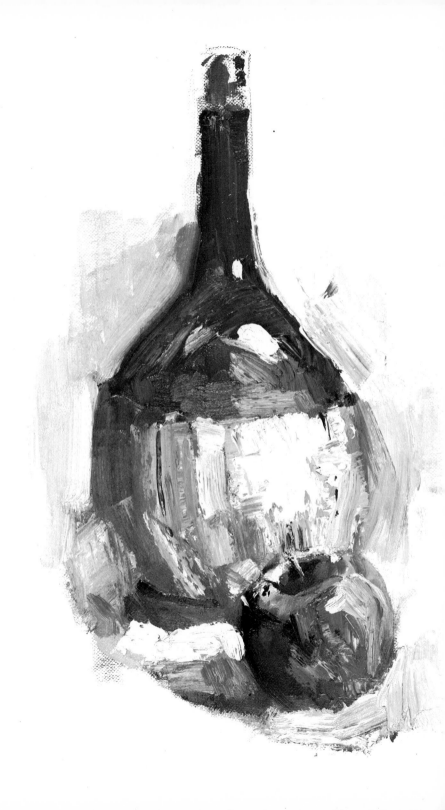

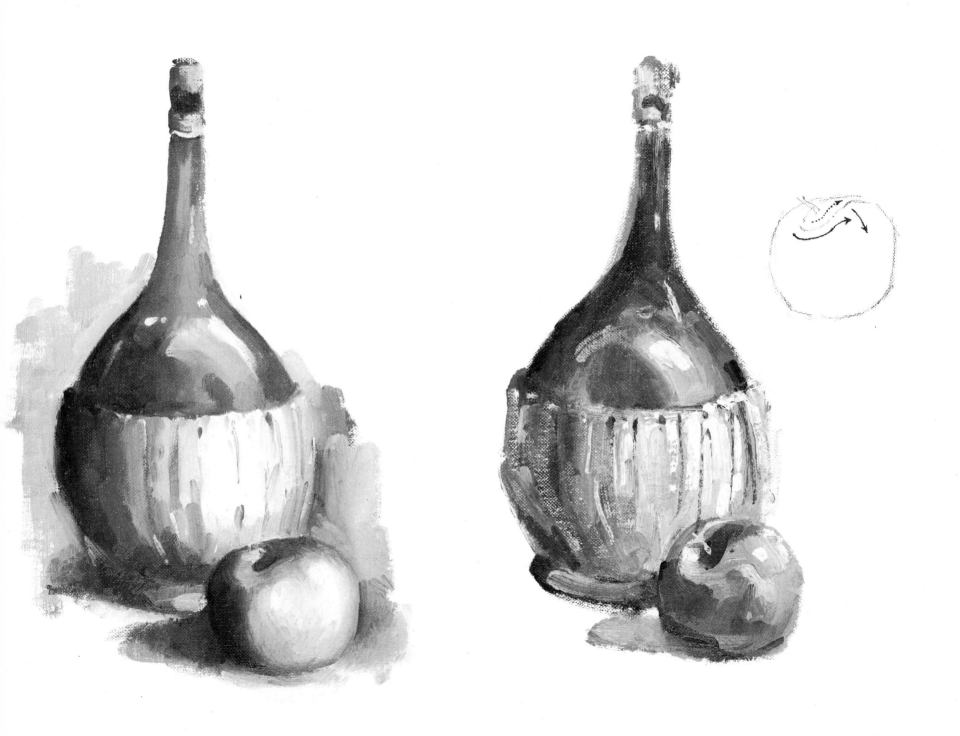

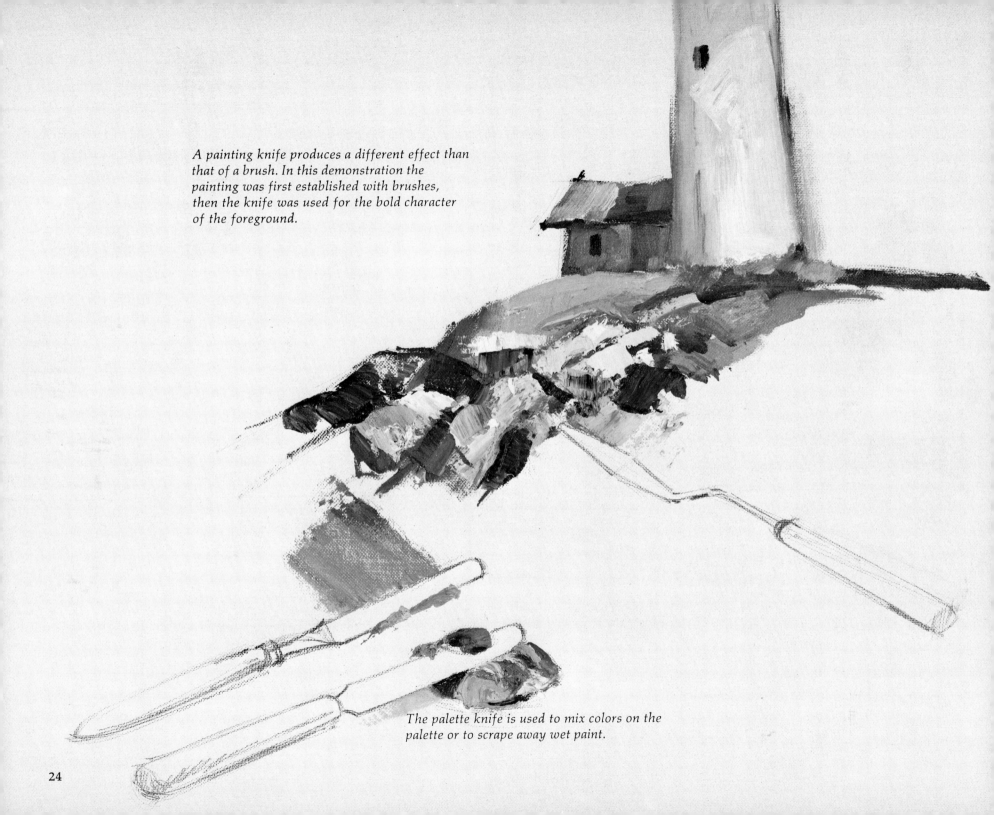

A painting knife produces a different effect than
that of a brush. In this demonstration the
painting was first established with brushes,
then the knife was used for the bold character
of the foreground.

The palette knife is used to mix colors on the
palette or to scrape away wet paint.

The terms *painting knife* and *palette knife* are rather confusing.
Palette knife painting is done with painting knives . . . not palette
knives. To put it another way: a thin, flat, flexible steel blade
set in a wood handle (spatula) is called a palette knife because it
was designed for mixing paint on the palette. Obviously someone
decided to paint with it — hence the term palette knife painting.
But somewhere along the way somebody designed a set of knives
with more flexible, various-shaped blades offset from the handles
for easier manipulation, to be used specifically for painting. These
are called painting knives, but we still refer to their use as
palette knife painting.

While some artists prefer to use only brushes for the actual
painting, others combine brush and knife, while still others work
entirely with knives. The effects achieved with the knife are quite
different than those produced by the brush. The blade leaves a
very slick surface when the paint is spread like butter. The tip of
the blade can be used to deposit distinct dabs of color. The edge of
the blade, dipped in a very soupy paint mixture, can produce thin
straight lines. In my own work I use the knife only as a supplement,
first resolving the total painting with brushes as much as possible.
Then, if there is an area that would be more descriptive if done
with a smooth blade, I don't hesitate to use it.

The tools and techniques you employ should contribute, not
detract, from the purpose of your painting. If your intention is to
express a realistic interpretation of nature, don't be so preoccupied
with the way you pile on paint that the surface itself becomes
more important than what you have to say.

Whether you choose to paint with bristle brushes, sable brushes,
painting knife or an old shoehorn makes little difference, as long
as you find it comfortable and capable of producing the effects
you're trying to achieve. The only way to determine which will
serve your purpose best is to experiment with each. Not all at once,
but in the course of time. A few medium-size bristle brushes —
#4, #8 and #10 — in flat and round shapes, would be good to
start with.

I had at first intended to title this section *Sit, stay . . . roll over*, for beginning to paint is like owning a new pup. It can be a lot of fun watching it romp and stumble with no inhibitions, but there should be a few obedience lessons if we are to enjoy the pleasure of its company later on. Otherwise it continues to devour paper and canvas, running from us when commanded to "stay."

On the following pages I have illustrated a number of brush techniques that I find most useful in my own oil paintings. These are relatively simple, for I'm primarily interested in shapes and color rather than subtle modeling of forms or detailed surface textures. Those textual indications that I do include are achieved by varying the direction, width and character of the brush strokes.

For practice work you'll find textured , plastic-coated canvas-like papers — available in pads — more economical than stretched canvas or even canvas panels. The individual sheets may be tacked to a board without any further preparation. The particular brand that I like and have used for many years is called Canvaskin, put out by Grumbacher. For more serious painting I prefer the real canvas, suitably stretched on a wood frame.

Most of the exercises shown here were painted without letting the underpainting dry. The important thing is to have sufficient paint on the brush to avoid the necessity of scrubbing the color onto the canvas. Lay the paint on as though buttering a slice of light soft bread.

Demonstrations A1 and A2 should be of particular interest to the beginning student who may not be aware of the freedom with which color may be applied in the early stages of the painting — or of the reason for smearing the paint beyond the edge of a form. This permits the refinement of the shapes in the latter stages without leaving a gap of raw canvas showing. The painting should be a matter of mass meeting mass rather than the filling in of outlines.

A-1 *Don't try to refine the objects in the first stages of a painting. Let your brush strokes extend beyond the edges.*

A-2 *Re-establish the edges later, by cutting back over the underpainting.*

B *To firm up an edge that's too soft, have sufficient paint on the brush to produce a clean, distinct stroke as you work back over wet paint. Using too little paint is a common fault of the beginner.*

C *Tonal or color variety within a brushstroke may be achieved by combining colors that are not thoroughly mixed. The demonstration on the left illustrates the effect produced. In the example on the right the colors were thoroughly mixed.*

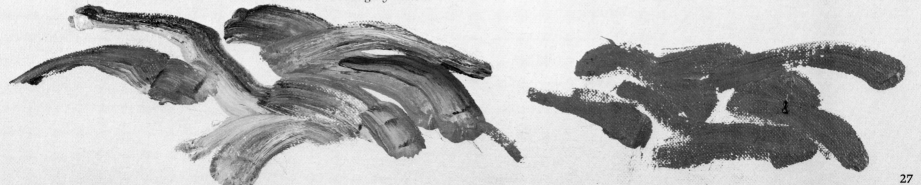

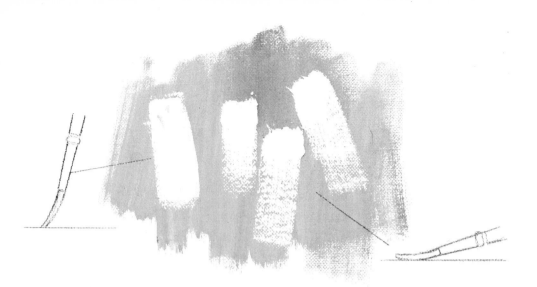

D Parallel-edged strokes produced by the flat type of bristle brush. The stroke on the left was done by holding the brush at a right angle to the canvas, so the paint was deposited by the tip of the bristles. For the other three strokes, the brush was held at an angle nearly parallel with the canvas so the paint was deposited by the side of the brush. This is less apt to disturb wet underpainting.

E Strokes made with a round brush have a tapered appearance. The grayer strokes in this example were made by pressing the brush firmly into a wet underpainting, causing the two tones to intermingle. The lighter strokes were laid over the wet underpainting with a delicate touch using the side of the brush.

F Linear strokes may be painted with a small brush or by turning a larger flat brush on edge. This latter method sometimes avoids the need to shift brushes in the process of applying both thick and thin strokes. The lines in this demonstration were painted over a dry underpainting.

G

To apply linear strokes over a wet underpainting, prepare a very soupy color by adding quite a bit of "medium" to the mixture. This will permit the color to be applied without excessive pressure of the brush on the wet underpainting.

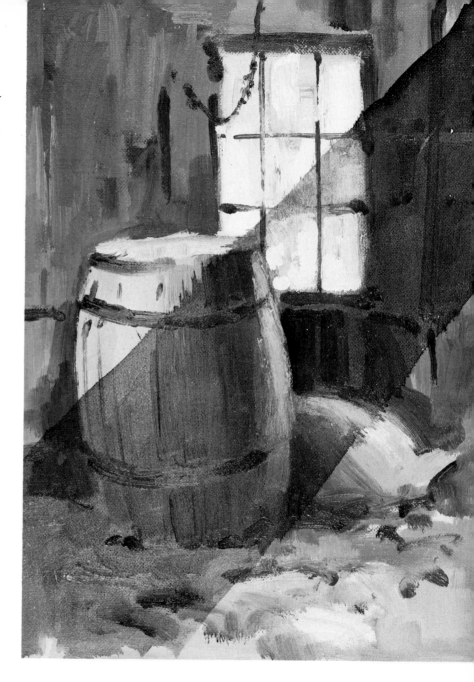

Oil glazing. The diagonal strip through the center of this demonstration shows the effect of a transparent layer of paint over an underpainting. This process achieves a luminosity of color and a unity of tone unlike direct oil painting.

Oils are considered an opaque medium, designed to cover the underlying color. The procedure for painting is to apply thin color first, thicker layers on top. But an exception to this general approach is the glazing technique, in which a thin transparent oil color is applied over a dried, thicker underpainting. The traditional method of working is to use a single color with white for the entire underpainting. In some cases a number of pale colors might be used. Since the overlaying color glaze does darken the surface, this must be taken into consideration when establishing the values. The painting is then allowed to dry, and the color glazes are added.

The color for the glaze is greatly thinned with a mixture of linseed oil, turpentine and damar varnish. This transparent color is brushed over the surface of the painting. In the demonstration on this page, the glaze is shown in the diagonal strip through the center. While this mixture was still wet, a clean rag was used to wipe away some of the color along the light side of the barrel and sack of grain on the floor. Then some opaque color was applied over the glaze on the window panes, in order to lighten this area.

Often a series of glazes are used, requiring a number of days for each layer to dry. As we'll see later on, this procedure is much faster with acrylics, requiring only an hour or less for the underpainting to dry. Why bother with this slow oil approach if acrylic is much faster? Simply because some artists still prefer the workability and other characteristics of oil paint.

29

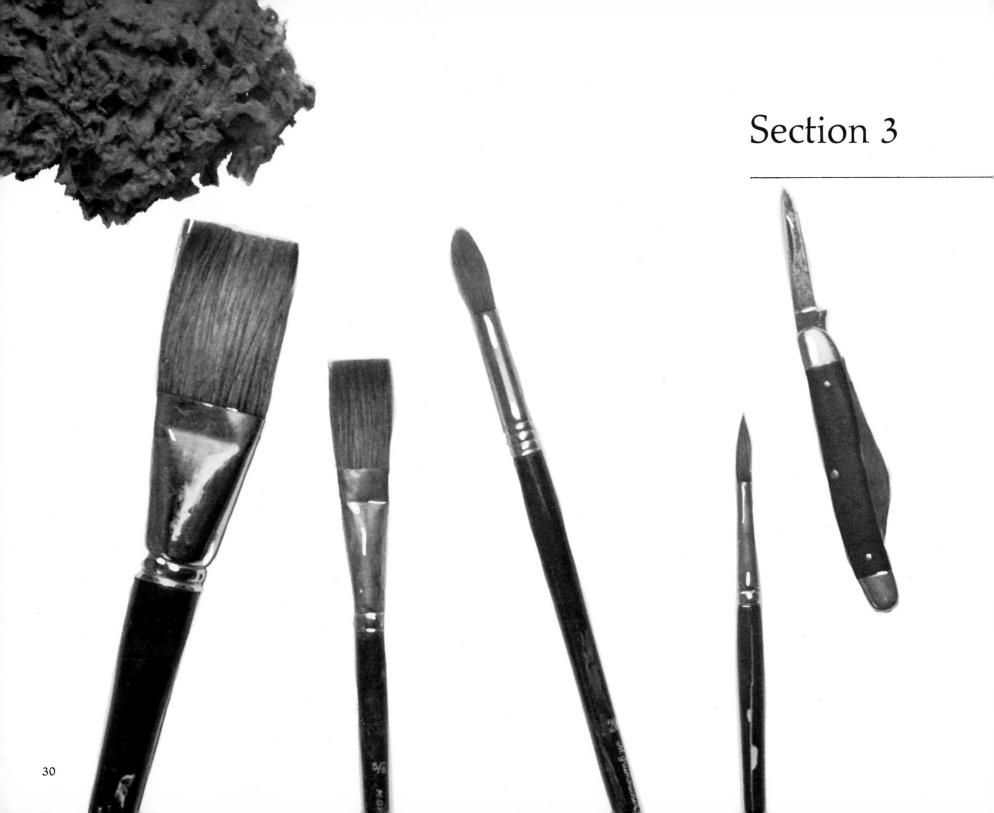

Watercolor painting

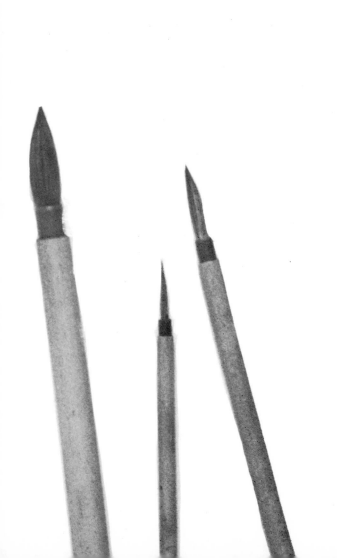

The first concern of the watercolorist is a good brush — one capable of holding lots of water and yet won't go limp when pressed to the paper. This is a tall order, and such brushes are quite expensive. A well constructed round sable brush is the first choice. Perhaps the most preferred size is the third brush from the left in the photograph. This is a Winsor & Newton #9. The sizes of round watercolor brushes (as well as all oil brushes) are designated by a number such as 00, 0, 1, 2, etc. Unfortunately this numbering is not consistent with different manufacturers, so it's difficult to refer to them unless designating the brand.

For sizes larger than the #9 shown here, flat brushes are generally used, like those shown on the left. These may be made of lesser quality material, such as ox hair or sabeline, for the flat construction enables them to hold quite a bit of water. Flat watercolor brushes are designated by the actual width: one-half inch, five-eighths, three-quarters, etc.

Those brushes with the light colored, non-tapered handles shown on this page are oriental bamboo. While not made of sable, and therefore lacking the "spring" of a fine brush, they do hold water quite well, and they are very inexpensive. I like them for certain techniques where the lack of control gives me a more spontaneous brush stroke. Sometimes the accidental strokes in a watercolor are more exciting than the pre-planned ones.

In the photograph I've also included a knife and a sponge, both useful pieces of painting equipment. I'll illustrate the use of the knife later. The sponge, either natural or synthetic, is used to remove color from the painting or to moisten the paper for certain effects. An item that I haven't included in the photograph is "Kleenex," indispensable for any wiping-up problems and sometimes used for blotting areas of the painting when you wish to lighten a color while it's still wet. I also use it to dry or partially dry the brush for special techniques.

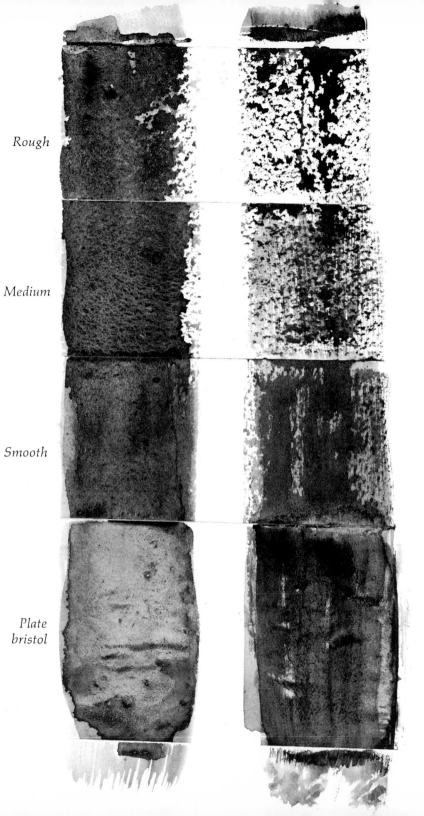

The roughness of the paper affects the character of the watercolor painting. The vertical stroke on the left was applied with a fairly wet brush. The stroke on the right was applied with a drier brush.

Rough

Medium

Smooth

Plate bristol

In this book I shall discuss watercolor as a transparent medium. That is, color applied in thin washes that allows the paper's surface or underlying colors to show through. The colors are lightened by adding water. Opaque watercolor refers to paints which cover the under surface, and are lightened by adding white.

With transparent watercolor, the type of paper used has an effect on the appearance of the painting. Usually, watercolor paper, made especially for artists, is the preferred surface. It has just the right degree of absorbency to take the paint well. However, some artists use other papers, such as Strathmore plate Bristol, not specifically made for watercolor, but which offer unusual qualities they find desirable. For the beginning painter I recommend the traditional watercolor paper, available in a smooth, medium or rough texture.

Since paper tends to buckle when water is applied to the surface, it's often the practice to soak the entire sheet in water for five minutes or more, then to mount the wet paper on a board and secure all four edges with gummed tape or thumbtacks. Then the paper is either allowed to dry, or you can begin work on the wet surface, depending on the effects desired. The paper will dry taut and flat.

Some artists prefer not to bother with this pre-soaking. The paper is taped or tacked to the board, and the buckling is either ignored or, if it becomes a hindrance, the painting is allowed to dry sufficiently to eliminate the buckling before proceeding.

When the watercolor is complete be sure to allow it to dry thoroughly before removing the tape or tacks so it will remain flat.

Generally I prefer tube paints, for it's too time-consuming to mix any quantity of color from cakes or pans. The colors are squeezed out onto the palette in quantities approximately sufficient for the day's painting. If any are left on the palette they'll harden, but can be used again at any time by moistening them with a wet brush.

A watercolor palette, because of the fluid manner of using the medium, contains depressions along the outer edge to hold the piles of paint. Mixing of colors is done in larger rimmed areas. Some artists prefer even larger areas than is provided by the usual palette, using what is called a "butcher's tray." This is a large enameled metal tray with a raised rim.

The procedure for mixing a color is to use the brush to transfer the necessary pigments from the piles to the mixing area. The brush is also used to transfer water from a container to the mixing area. Water is the means by which a color is lightened. However, for even the very darkest tones a bit of water must be added to the pigment to make it fluid enough to brush onto the paper. If the quantity of paint required is only about a brush full, it may be better to mix the pigments first — then add the necessary water. For larger quantities it may be more convenient to put out the water on the tray first.

Since water is used to rinse the brush as well as for color mixing, it's advisable to keep it in a container large enough to avoid the necessity of changing it too frequently . . . a quart size or larger is recommended.

Color is but one factor in painting a watercolor. The manipulation of the brush, the texture of the paper and the condition of the paper — whether it's wet or dry — can all contribute to the final result. The examples in this section illustrate some of the effects of these controls.

They say that dogs often resemble their owners. I feel this is also true of watercolors and their creators. The lively brushwork of Claude Croney is certainly reflective of his own extroverted personality. John Pellew's relaxed yet refined manner is evident in his fine paintings. The casual, unpretentious but sensitive work of Charles Reid plainly describes the artist himself. These similarities are not deliberate, but the outgrowth of their own inner feelings.

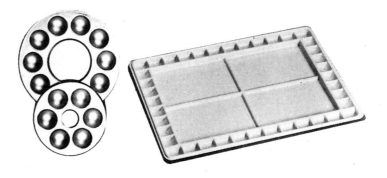

Watercolor palettes

Butcher's tray

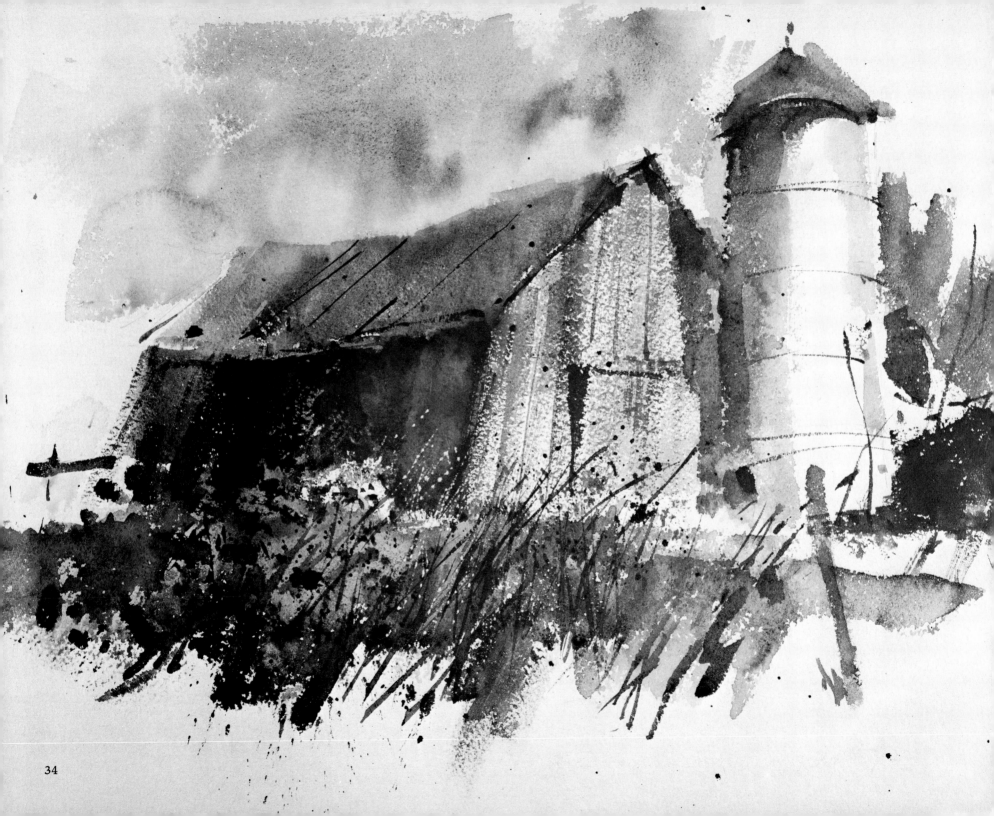

34

*The painting at the left shows a bold application
of watercolor on rough paper, with emphasis
on the textural qualities of the elements.*

*A more controlled painting approach, with the
emphasis on shapes and subtle tonal relation-
ships. This was done on a smooth watercolor
paper.*

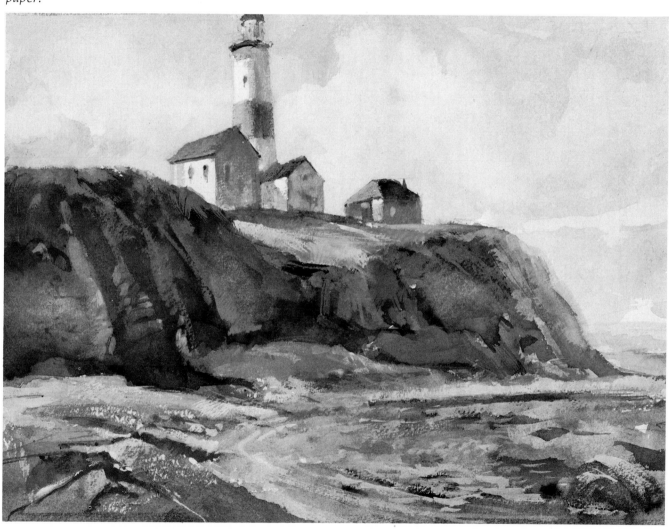

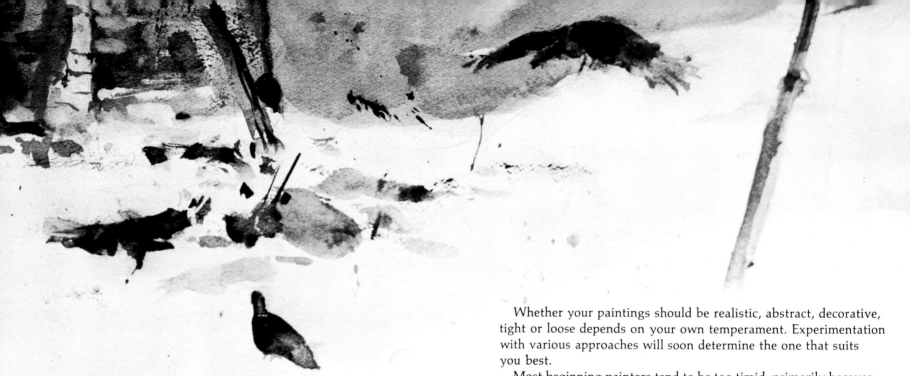

Whether your paintings should be realistic, abstract, decorative, tight or loose depends on your own temperament. Experimentation with various approaches will soon determine the one that suits you best.

Most beginning painters tend to be too timid, primarily because of the fear of spoiling the paper. They fill in each area with a series of short dabs with too little paint on the brush. Thus the painting lacks any of their own personal character.

When it comes to my own watercolors, I personally find those done quickly and with utmost brevity the most satisfying. In this way I avoid irrelevant detail and overworked passages. And I feel the results evoke a sense of mystery by what is left unsaid . . . the images are there, but the viewer's own imagination must supply the details. The painting at the right, entitled Turkey Vultures, illustrates this point. The subject is a scene near Green Peak, in East Dorset, Vermont. It's an old abandoned iron furnace, surrounded by undulating snow-covered ground and sparse winter trees. Painting quickly, with limited colors and a large brush, I tried to establish this locale with simple, almost silhouetted, shapes. The furnace itself has been treated quite simply, although developed in more detail to establish that it's made of stone. Painting of the birds (see detail above) was purposely kept rather vague, for I felt that to render them more clearly would take away some of the mystery. Their presence should only be discovered after the viewer has taken in the rest of the subject. So I used the title to identify the species and to entice the viewer to look for them.

TURKEY VULTURES
Watercolor on a medium surface watercolor paper, 19 x 29 inches.

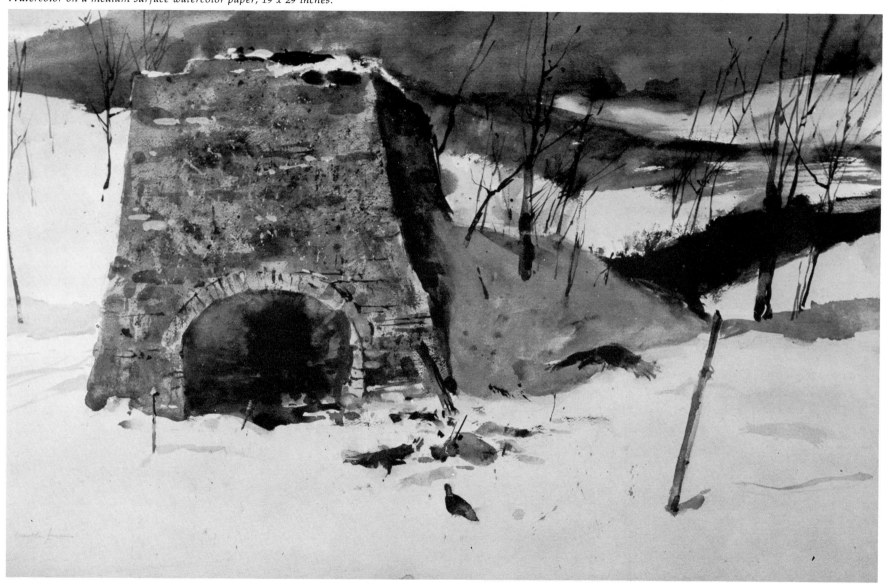

The word *technique,* used so profusely in my text, is defined as a method of accomplishing a desired aim. On the following pages I've demonstrated some of these methods where the aim is to produce the textural qualities of the forms in nature. As you'll note, they are quite abstract when considered separately; but, combined or used within the framework of a painting, they can express the reality of life around us — from soft delicate clouds to the roughest of stone — from windswept fields of grass to the sparkle of ocean water.

Many of these methods will respond differently, depending on the paper used. I suggest that you try them on various surfaces, from smooth to very rough, so that you can anticipate the effects you may get.

Long fine lines are perhaps the most difficult of the brush strokes to paint. With most other techniques the brush is held so that your hand does not come in contact with the paper. For medium fine lines, or if I want a drybrush effect as shown in the example, I rest the back of my fingers on the paper, making certain any color underneath is dry so I won't smear it. The brush is then dragged across the paper much the way you might pull a sled across the snow. By keeping the angle of the fingers constant you can control the tip of the brush so it maintains an even pressure on the paper. Move your hand quickly and smoothly across the surface in one continuous motion to keep the brush from wobbling.

For extremely fine lines have the tip of a well-pointed brush just barely touching the paper. Keep your hand well down on the handle and hold the brush in a vertical position. The side of the last two fingers should rest on the paper.

Drybrush refers to color that's applied in such a manner that the paint is deposited on the raised bumps of the paper, leaving the white of the paper showing in the depressions. This technique is most easily done with a wide flat brush on rough watercolor paper. The brush should either be fairly dry or the strokes made lightly and quickly.

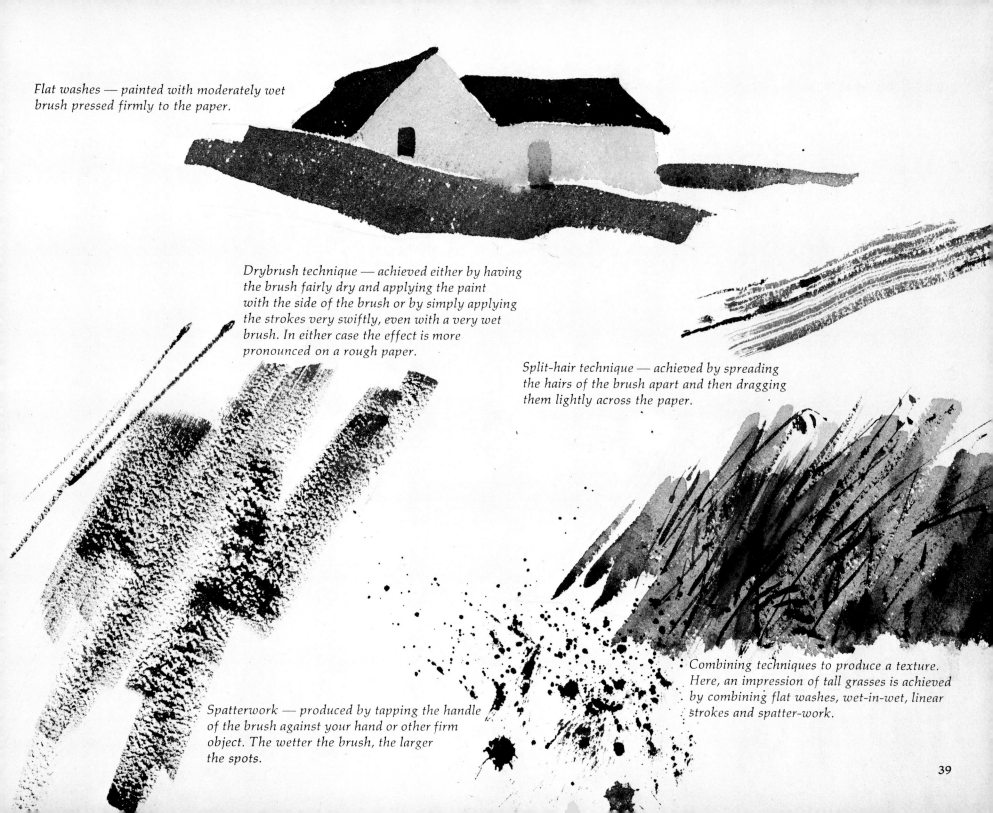

Flat washes — painted with moderately wet brush pressed firmly to the paper.

Drybrush technique — achieved either by having the brush fairly dry and applying the paint with the side of the brush or by simply applying the strokes very swiftly, even with a very wet brush. In either case the effect is more pronounced on a rough paper.

Split-hair technique — achieved by spreading the hairs of the brush apart and then dragging them lightly across the paper.

Spatterwork — produced by tapping the handle of the brush against your hand or other firm object. The wetter the brush, the larger the spots.

Combining techniques to produce a texture. Here, an impression of tall grasses is achieved by combining flat washes, wet-in-wet, linear strokes and spatter-work.

39

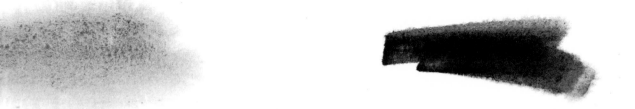

Wet-in-wet is achieved by applying paint to a surface that is already wet. Varying the amount of water and pigment on the brush will affect the spread of the added color as shown in this demonstration. The example on the left was done with a very wet brush — little pigment. The one on the right was done with very little water — lots of pigment.

The wetness of the paper also affects the spreading of the color. The same color mixture was used for each of the three strokes in this demonstration, but the paper was allowed to partially dry between strokes. The wetter the paper, the more the color spreads.

Very often it's desirable to have one color blend into another to produce an indistinct edge where the two colors meet. The extent to which one color will blend into another is determined by the wetness of the previous wash and the amount of water in the mixture on the brush. On the opposite page are two methods of controlling this spread of color. In actual practice the condition of the paper at the moment and the lightness or darkness of the color desired would determine the more desirable method.

There are times when working with watercolor that it's not practical to leave the white of the paper to represent white shapes, especially when these shapes are so small that it would be difficult to paint around them. In this case you might use opaque white paint, or you can scratch away the color with the point of a knife.

Both methods have been used in the example at the right. The white flowers around the base of the tree and the two light branches running diagonally across the tree trunk were put in with a fairly thick mixture of opaque white paint. I made the very thin lines representing the stems around the base of the tree by scratching the paper quite firmly with the point of a sharp knife. The paper should be dry when this is done so that the fibres do not pull apart. The side of the knife's tip is used to scrape the paper, rather than using a cutting stroke.

In this illustration a knife was also used to produce the texture on the trunk of the tree. Here the sharp edge of the blade, rather than the tip, was scraped across the surface. The quality of the paper has an effect on the final results and requires some prior experimenting on the part of the artist.

Scratching, scraping, or using opaque white are not techniques that one should abuse. Their use should be limited to minor adjustments of the painting and not to the extent that they are obvious to the viewer. We'll see an example of their application in the step-by-step watercolor demonstration in Section 6.

While discussing the use of white paint, I should mention that there are times when it's also used in color mixtures, not to produce an opaque paint, but to achieve a certain color quality that cannot be obtained otherwise. If, for example, a little white is added to a deep red, the resulting pink will be quite different than that produced by lightening the red with only water. Adding white to mixtures of grays or blues results in a certain softness of color that is sometimes desirable.

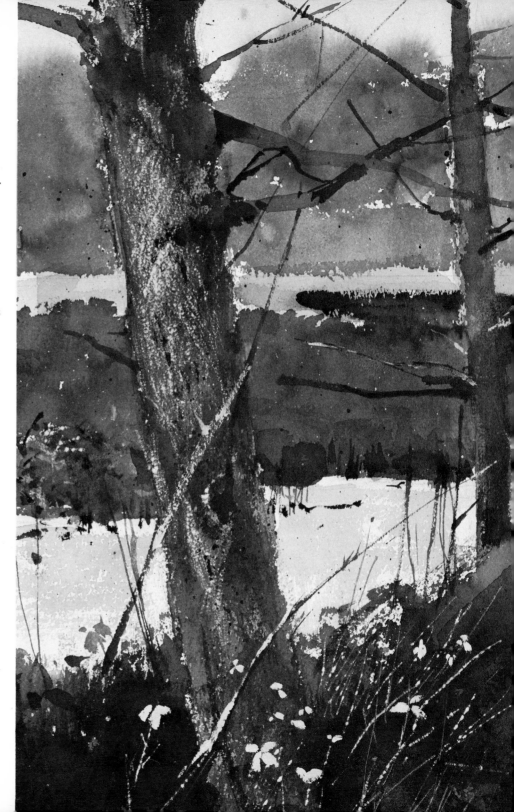

It often seems to come as a surprise when I mention that a water-color painting can be corrected. While it's true that corrections cannot be made as easily as with opaque mediums, the painting may be altered by scrubbing out the color with a sponge. The extent of the scrubbing that's possible depends to a great extent on the strength of the paper. Heavy weight, professional grades of water-color paper such as d'Arches, Grumbacher, Strathmore, Millbrook or Fabriano will withstand extensive scrubbing without damage to the surface. Student grades of watercolor paper are more delicate. In either case the sponge should be kept quite wet and rinsed frequently as you remove the color. Certain colors are easier to remove than others. Those containing dye pigment tend to penetrate the surface of the paper, but even these can sometimes be lightened sufficiently to permit corrective overpainting. Earth pigments such as the umbers, siennas and ochres are the most easily removed.

If the area to be corrected is very small, making it difficult to confine the scrubbing, masking tape may be applied around the shape before doing the sponging.

Or, instead of a sponge, you can use a brush wet with clear water for small areas. This gives you a fair degree of control without the need to apply a mask, although the edge of the lightened area will not be quite as distinct as with the taping method.

Painting is more than the rendering of objects, more than brush techniques contrived to simulate nature. It's an expression of your innermost feelings as you observe a bit of life at a given moment. It isn't the skillful draftsmanship that determines the value of art, but what the artist has expressed with those skills he possesses. A sheet of paper or a piece of canvas filled with impressive passages of paint may be quite empty of content.

I'm reminded of a friend who moved to Alaska some fifteen

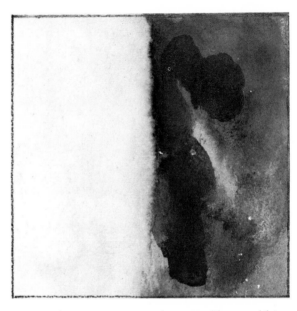

Watercolor pigments may be erased by scrubbing the paper with a wet sponge, as shown in the left half of the square. Colors like the umbers, Hooker's green and cerulean blue are easier to remove. Alizarin crimson, Prussian blue and viridian are difficult.

years ago. He had never painted so knew nothing of drawing, painting procedures or techniques, but when he saw the magnificence of the surroundings as he fished and hunted and learned to know the land with considerable intimacy . . . he had to paint. His wife gave him an oil kit for Christmas. Totally untutored, he plunged in. Over the next year or so he had produced some two dozen paintings.

"You won't find any masterpieces here," he comments, "I painted them only for my own satisfaction."

On close examination John's struggles with the medium were evident. The paintings were crude, overworked and out of drawing. But beyond these limitations they vividly expressed the beauty of the mountains, the loneliness of a trapper's cabin or cache, the excitement of moose and caribou poised in their natural surroundings, more eloquently than the work of many schooled artists.

Certainly we want to learn as much as possible about the procedures, use of the medium and color principles, in order to express our ideas most clearly and with the least difficulty. But the point of the story is that regardless of your technical skill, whether it be minimal or highly developed, the real worth of your painting is in its ability to evoke an emotional response. You're most likely to achieve this if you paint those subjects you know; get to know those you want to paint. Then you'll transform those yellow and ochre passages of paint into a vast hayfield under a burning August sun, and we'll sense the coming thunderstorm in that leaden gray sky just edging into the painting. We'll know the character of the people who live in the houses of your cityscape and almost smell the burning leaves from the curl of smoke at the side of the road in that autumn landscape.

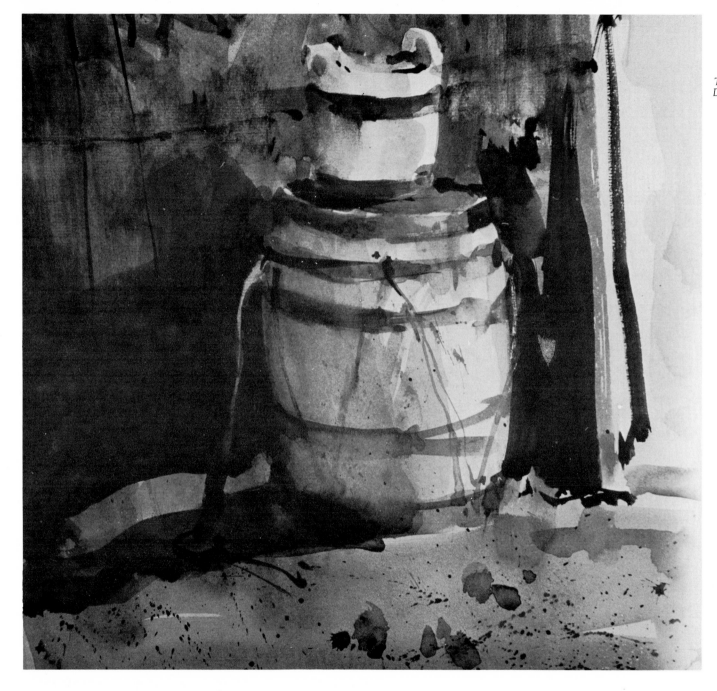

TRAPS
Detail from watercolor

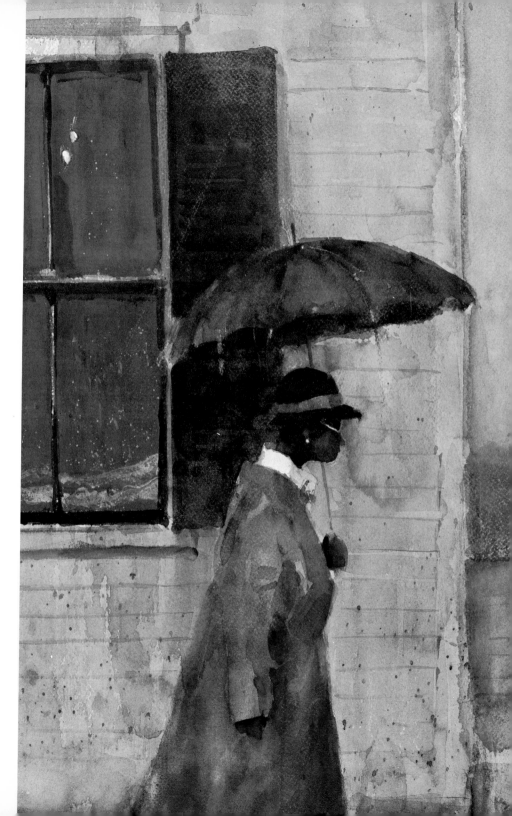

On these pages are sections taken from larger paintings. The two pieces are different in character, partially because of the papers on which they were painted, but more importantly this difference is the result of my own feelings as I observed the scenes. The barrel is from a painting of the interior of a salt water fisherman's shack. As though sketched with the swift movements of a pencil, the brushwork is direct and positive, emulating the rugged character of the place itself and the fisherman to whom it belonged. No frills, no fuss . . . just the simple statements of light and shadow.

In contrast is the handling of this section from a painting entitled *Summer Rain*. More delicate use of the brushwork, soft and blurred as though dampened by the rain itself. The somberness of the figure is repeated in the simplicity of the washes and in the placid shapes within the painting.

From these examples you can see that surface textures do not have to be stressed. The extent of their use should directly relate to the story you're trying to convey. Subdue those that do not, in your opinion, directly contribute to the visual impression. Don't put in things just because they're there. And what you do put in, control . . . so it receives only the importance it deserves. In *Summer Rain*, for example, the slats in the dark shutter are barely evident, for it's the overall shape that identifies it as a shutter. Emphasizing the slats might destroy the simplicity of the shape. On the other hand, I did feel that the indication of clapboards contributes to the description of the type of building and at the same time provides a contrasting texture for the simpler washes. Even so, I tried to keep the lines fairly subtle, so as not to destroy the large light shape of the building.

As I mentioned, these watercolors were done on different types of paper. The barrel, from a painting entitled *Traps,* was done on the smooth surface of mat board (the heavy cardboard used to frame the borders of a watercolor). *Summer Rain* was done on Crescent illustration board (a slightly textured paper with a firm cardboard backing).

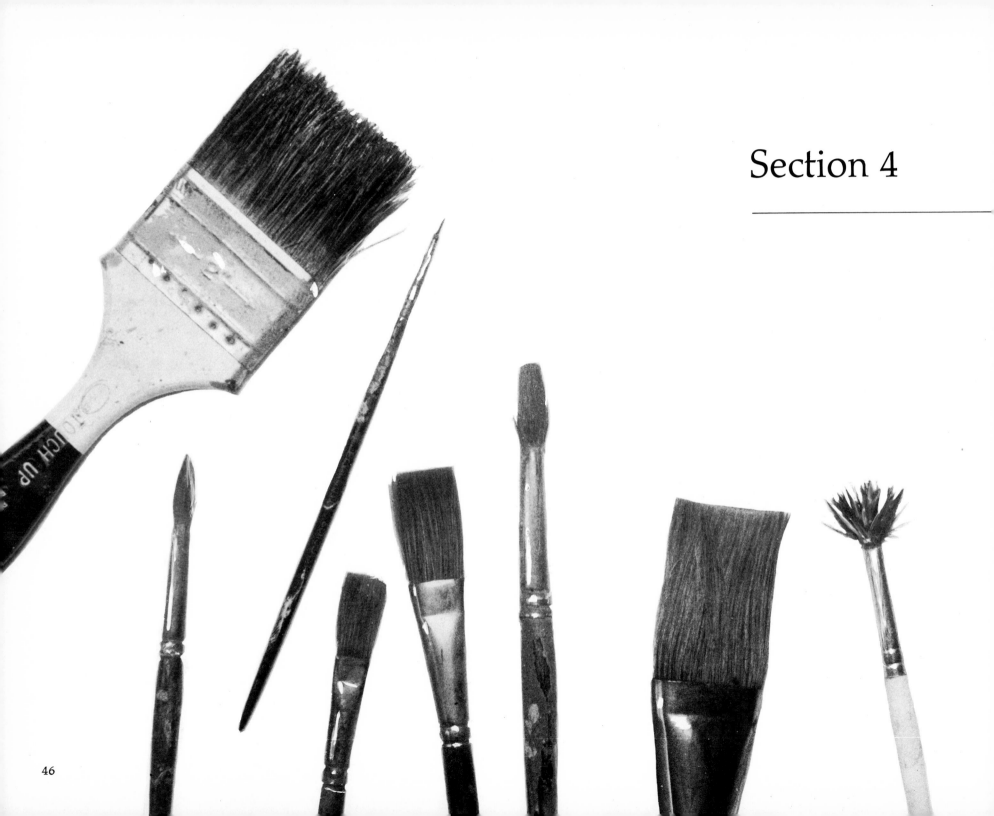

Section 4

Acrylic painting

The variety of brushes shown on these pages gives some indication of the flexibility that I enjoy with acrylic paints. The two-inch housepainter's brush shown at the upper left is principally for applying the gesso ground to the Masonite on which I paint, but I also use it occasionally for applying large areas of color in the underpainting. In ridiculous contrast to this, the tiny, almost hairless, brush below it is used for the tempera approach, in which the paint is applied a stroke at a time. In addition to these extremes I generally use any of the brushes that I employ for watercolor, and occasionally some oil brushes. I would advise not using the same sable brushes that you use for watercolor, but keep a different set of the same type.

That bedraggled brush, with the hairs looking like they'd been frightened by a ghost, is of a cheap camel's hair variety. It doesn't hold water and it won't come to a point any more. But I use it when I want to jab the paper's surface to produce a nondescript bold stroke or to make multiple hair-like lines by dragging it across the surface.

Brushes used with acrylic definitely require more care than with either of the other mediums. They must be thoroughly washed before the paint hardens. I rinse them as soon as I've finished applying color, then lay them on their side in a shallow dish with the hairs immersed in water until I'm through painting for the day. Then I wash them out with soap and water.

When I use Masonite as a painting surface (one-eighth inch untempered) I coat the smoother side with four or five applications of acrylic gesso. This is applied either with the housepainter's brush or, for a smoother finish, the sponge type of brush shown at the right. The surface can be smoothed further by sanding, although I don't usually do so.

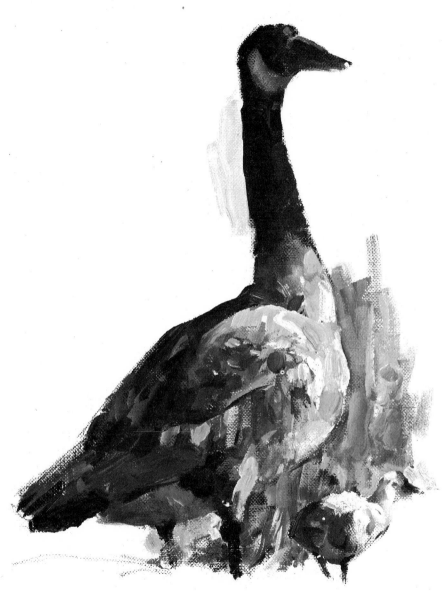

Acrylic paints applied to canvas in the manner of an oil painting.

Many questions arise with regard to this newest of mediums, for it has only been available to the artist in recent years. How does it differ from other mediums? Should it be used like oil or watercolor? Is it easier to use than the other mediums? It dries so fast; how can I slow it down?

As already stated, acrylic paintings may look like either oils or watercolor in appearance. It is how the medium is used that makes the difference. In the demonstration on this page, I've applied acrylic to canvas in the same manner as oils, with a very similar appearance. Those brands that I've used are not quite as firm as oils, so the paint tends to smooth out with less evidence of brush marks. It responds like butter that's been left out in a warm room. For this reason little or no "medium" is required to brush out the color for thin passages.

The major differences between oils and acrylics are the drying time and the fact that water is used with acrylics. (I'm sure some people prefer this medium because it's odorless and requires only soap and water to clean up.) In reference to the drying time, I made a test indoors on a moderately humid summer day and found that thin applications of color on canvas dried within a half hour. Thicker areas began to dry on the outer surface in about an hour. The piles of paint on the palette remained usable for a number of hours. Outdoors, in direct sunlight, drying is accelerated. The thin applications dried in about five minutes; thicker areas and the piles of paint on the palette began to dry on the outer surface in about twenty minutes. The piles of paint can be used for a longer period by pulling back the dry outer skin. There is a retardent available that will slow down the drying to some degree, its effect more apparent in the piles than in the brush work.

Acrylics may be used just like transparent watercolor and the visual appearance is similar. On page 49 is a painting done on watercolor paper in which I purposely emulated the same brush-work used in the watercolor on page 32. When using this approach the brushes are the same as those used for watercolor.

The only difference in the two mediums is the fact that acrylics dry completely waterproof. This affects certain techniques. With watercolor you may lift out a color that has dried by scrubbing

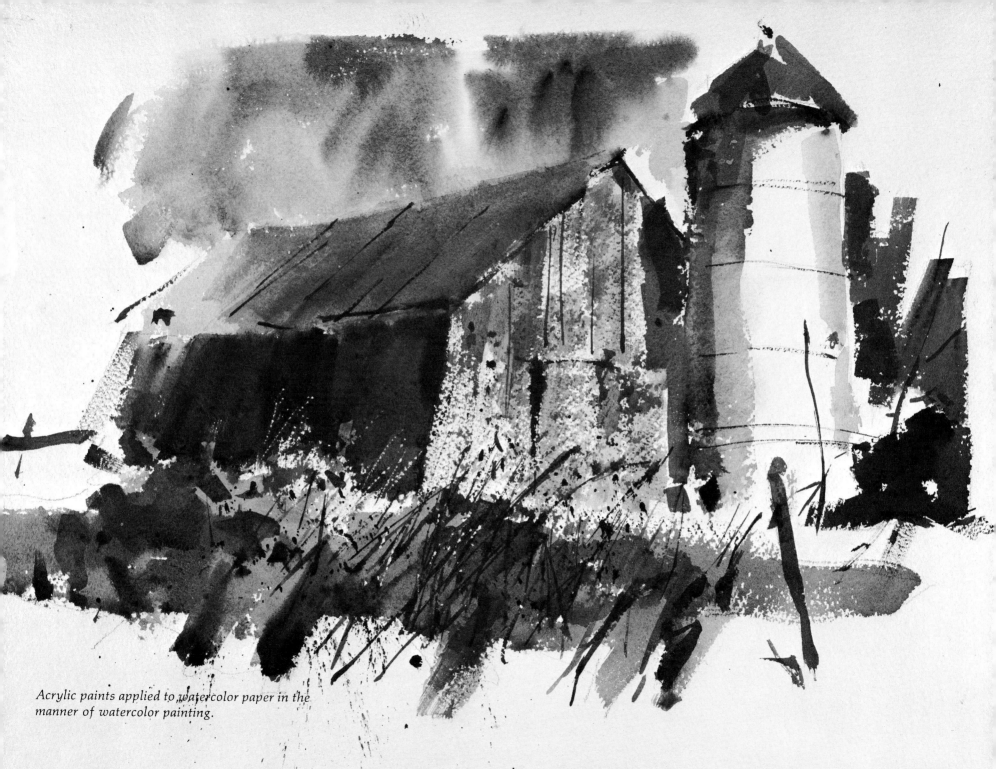

Acrylic paints applied to watercolor paper in the manner of watercolor painting.

49

it with a wet brush or sponge. Thus areas may be changed or an edge softened. Also, with watercolor, a wash may pick up some of the previous color that has already dried. This doesn't happen with acrylic. Once dried, an area cannot be scrubbed or lifted out. Corrections have to be made by painting over it with an opaque mixture.

Both for artistic expression and permanence, acrylic offers a latitude that exceeds either oil or watercolor. It may be applied to any surface that is not slick or oily. The combination of transparent and opaque passages in the same piece is most compatible. It can be applied very thickly to a flexible material such as canvas or paper without cracking or flaking off. And the structure of the paints makes them especially transparent, with an intensity of color that appears to exceed that of the other mediums.

Acrylics should not be combined with or painted over oil paints or oil-primed canvas. However, oil paints may be applied over acrylics. (Some artists prefer to use acrylics as an underpainting, completing the painting in oils.)

Another medium, which I shall not discuss at any length in this book, is called *egg tempera*. The traditional method of applying this medium is to build up the various tones by using a network of fine overlapping strokes applied with a very small brush. Notable examples of this technique are the egg tempera paintings of Andrew Wyeth. Acrylic lends itself very well to this same procedure. *The Canada Goose* on the opposite page (lower) illustrates this fine line treatment in acrylic.

A fourth painting approach, which I prefer when using acrylics, is perhaps most closely related to that used for egg tempera. But rather than refining all of the forms with fine lines, the finished work consists of a combination of watercolor, tempera and oil techniques. As with a tempera painting, the color is applied to a gesso panel in thin layers so that the surface remains quite smooth. The treatment may be very bold or carefully refined, depending on the subject. *The Gray Goose* on the upper part of the page illustrates the approach. In this particular demonstration I haven't refined the painting, so that the various techniques may be seen more easily.

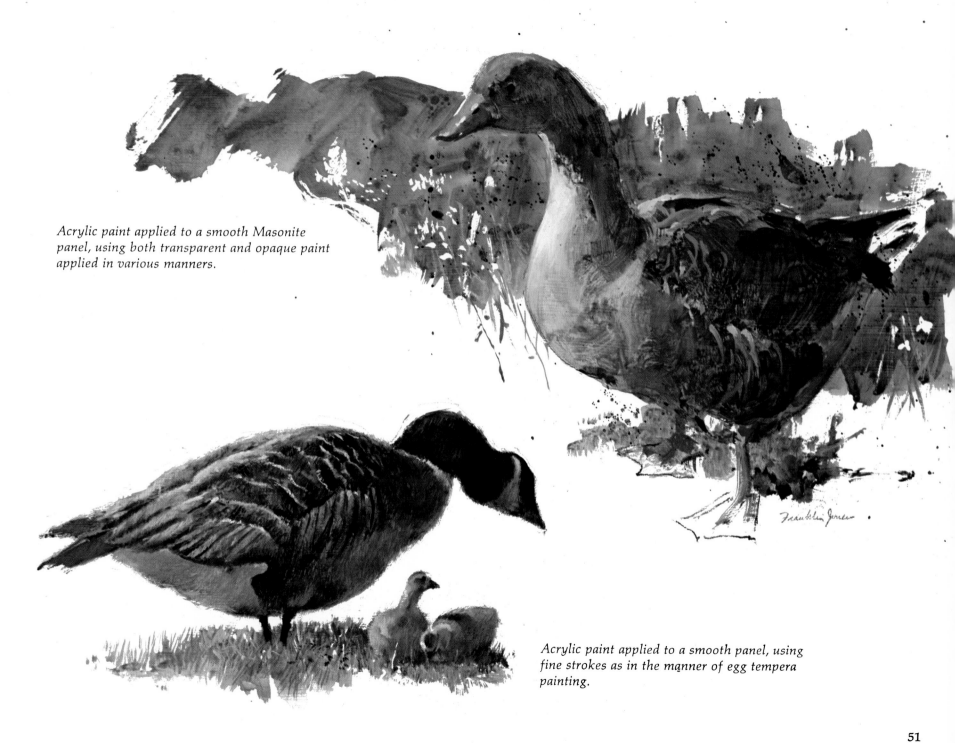

Acrylic paint applied to a smooth Masonite panel, using both transparent and opaque paint applied in various manners.

Acrylic paint applied to a smooth panel, using fine strokes as in the manner of egg tempera painting.

The methods for creating textures described on the following page are some that I employ in my own paintings. In addition, of course, I may use any of the techniques discussed in the oil and watercolor sections.

The long horizontal bit of painting shows the kind of brushwork I frequently use to lay in the initial tones. It's a combination of fluid transparent washes quickly applied and very dry color pounced, jabbed and dragged across the surface. This is where I might use either the two inch housepainter's brush or the bedraggled camel hair. Frequently I'm able to retain some of this brushwork in the final painting just as it is, or by applying additional colors over it to lower the value. You'll see an example of this approach in the illustration on page 59. The ground, stone wall and even the woman's skirt are pretty much the way I scrubbed them in.

The demonstration in the lower left corner illustrates spatter-work and an application of flat opaque color. The spatter-work, both light and dark, is a technique that I find useful for expressing a variety of surfaces. If the brush is fairly dry and the handle is struck lightly against the edge of a firm object such as a ruler, the resulting effect is a spatter of tiny specks. Add more water to the brush and the drops of paint will be larger. This is one technique where you have to watch your shirt, dress or the nearby wallpaper or you'll have some washing problems. Acrylic happens to be a great fabric paint and doesn't wash out. Of course, you can always paint over the spots to match the fabric!

The demonstration in the lower corner shows another surface texture. This is produced by vigorously scrubbing the gesso surface with a very wet, very transparent mixture and then quickly drying it with a hairdryer before the bubbly mixture has a chance to disperse. This was repeated a number of times in the lower section to make the mottled effect more pronounced.

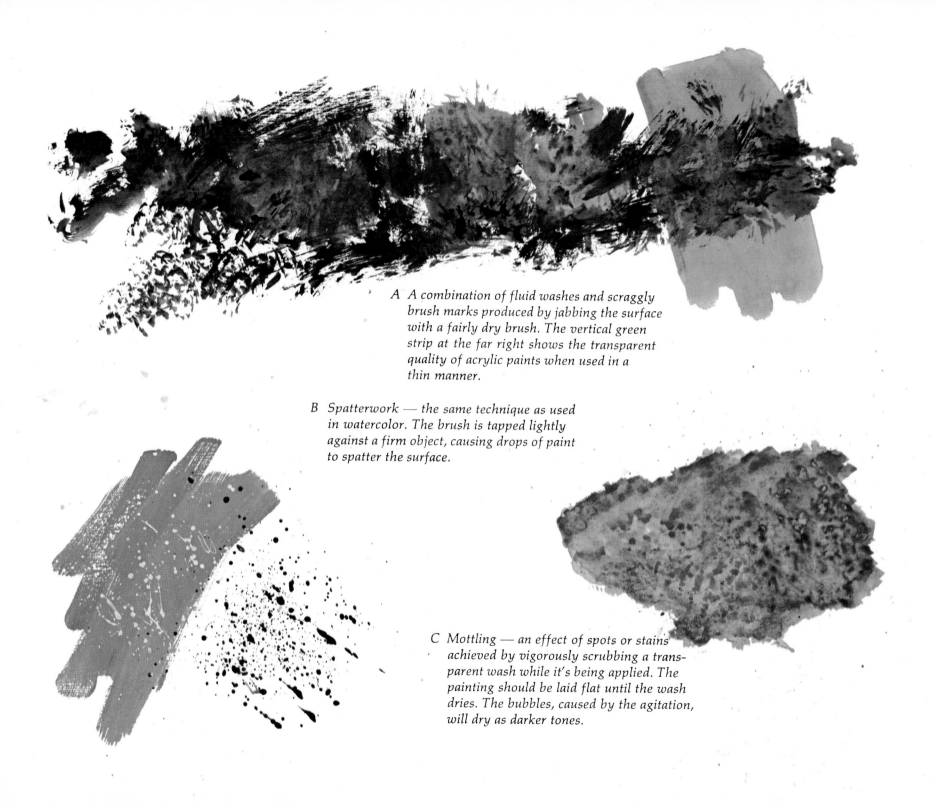

A A combination of fluid washes and scraggly brush marks produced by jabbing the surface with a fairly dry brush. The vertical green strip at the far right shows the transparent quality of acrylic paints when used in a thin manner.

B Spatterwork — the same technique as used in watercolor. The brush is tapped lightly against a firm object, causing drops of paint to spatter the surface.

C Mottling — an effect of spots or stains achieved by vigorously scrubbing a transparent wash while it's being applied. The painting should be laid flat until the wash dries. The bubbles, caused by the agitation, will dry as darker tones.

I've shown an effective technique for producing the textural quality of stucco or certain types of rock surfaces in the step-by-step demonstration at the top of the next page. The first step is the most difficult, for white paint has to be dragged across the surface and then delicately re-dragged until it forms minute ridges and balls of paint. An easier way to produce this roughness is to add fine sand to the white paint. However, for my work, since I prefer to keep the entire painting very flat in appearance, the sand builds up the surface too much. For your own manner of working, you may find the sand a suitable material, and it's very compatable with acrylic paints.

The remaining steps of the technique are very easy to control, and if the results aren't satisfying, the procedure may be repeated again and again. An example of the application of this method is shown in the reproductions on pages 56 and 59.

The technique shown at the bottom of the page produces a hazy or smoky effect. It has various applications, but is especially useful for creating atmospheric haze on distant areas of a landscape. The procedure is similar to applying a transparent glaze, but white paint, which is more opaque than most colors, will produce a semi-transparent glaze.

The underpainting which is to be affected by the haze should be completely resolved before using this technique, and the fact that haze lightens the tones means that the area should be initially painted darker than you intend it to be in the final painting.

The techiques discussed here are just a few of the possibilities available to the artist using acrylics. I've mentioned them not so much as a specific means of painting, but to indicate the flexibility of the medium. The varieties of effects are limited only by the imagination.

Stucco effect — Step 1
Thick white paint is delicately brushed across the surface. As the paint is drying it is continuously brushed in one direction so as to form minute granules and ridges.

Step 2
The white paint is allowed to dry. Then a thin wash of appropriate color is applied to the area.

Step 3
The color is allowed to dry. Then more white paint is lightly brushed over the surface in one direction, so that it is deposited only on the raised part of the granules.

Step 4
Another transparent wash may be applied to give some color quality to the white highlights.

Hazy effect — Step 1
The area to be affected by the haze is completed and allowed to dry.

Step 2
A thin semi-transparent mixture of white paint (plus a bit of color, if desired) is brushed over the area. This may be allowed to dry as is, or apply Step 3.

Step 3
To produce an uneven tone, gently wipe the area with a crumpled Kleenex while it's still wet. Work quickly, for the thin layer of paint dries very fast.

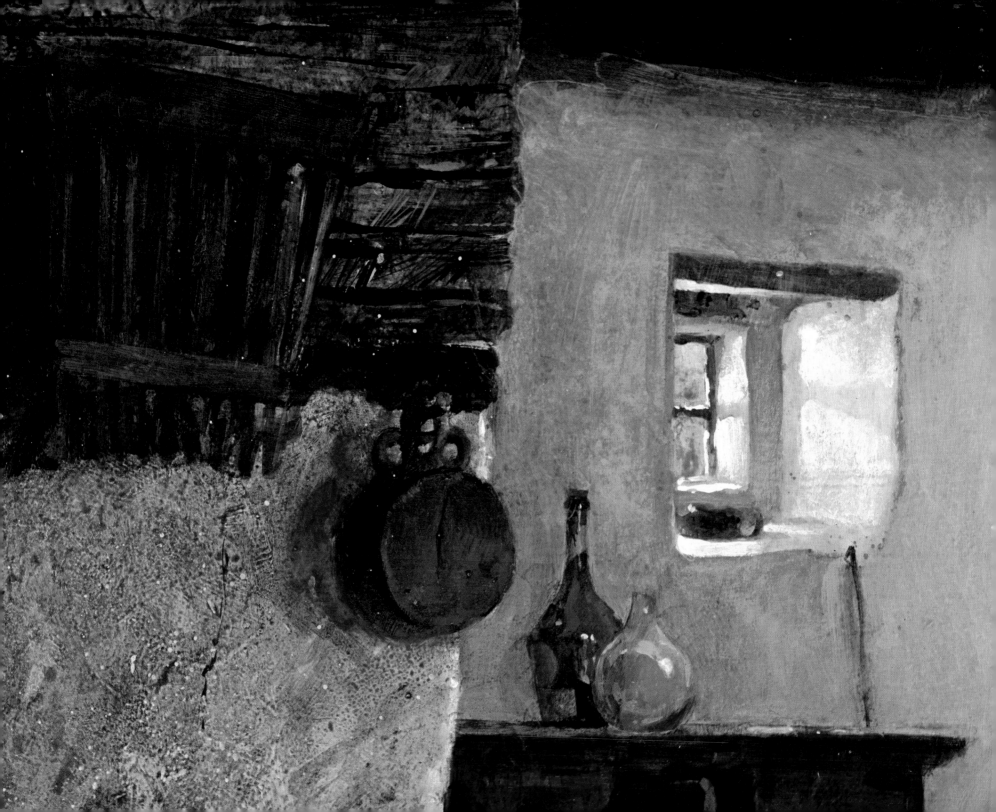

Actual size detail from acrylic painting, THE CORNER WINDOW.

The total time involved in an acrylic painting, for me, may be a couple of weeks, especially if I use the tempera technique extensively, or if a developed area doesn't satisfy me and I have to redo it. For the amount of detail involved, however, it's still a very fast medium to work with.

As with any of the mediums, it's important to keep moving from area to area during the various stages of the painting, so that it develops as a whole. It's difficult to control the relationships of values and textures if too much time is devoted to a single area.

Shown here is an actual size detail from a 20 x 30 inch acrylic painting entitled *The Corner Window*. It illustrates a variety of techniques and the resulting textures that are possible with this medium.

The dark tones of the old beam in the upper left corner were established in the first stages of the lay-in. Here is an example of where the texture proved sufficient for the final painting. The blackened candle mold was added with opaque color.

The plaster wall directly below is a combination of techniques. First the surface was roughened as previously described on page 55. Over this I applied transparent glazes, scrubbed on vigorously to give them a bubbly character. A light-colored spatter was added, plus some fine linear strokes.

The wall surrounding the window, being further back in the scene, required less emphasis on the surface texture. A semi-opaque, milky mixture was brushed over a darker undertone and then lightly wiped with a dry tissue.

I painted the bottles with a series of minute overlapping strokes to achieve the subtle color and value changes. My overall procedure is to work from light to dark, but for the bottles I started with a dark tone and slowly built up to the final highlights.

Just as there are two basic vehicles for thinning oil paints (turpentine and linseed oil) so there are two means of thinning acrylics (water and acrylic emulsion). In the same way that too much turpentine destroys the binding quality of oil paint, too much water will destroy the binding of acrylics. The advice of the manufacturers is to not add more than fifty percent water to a paint mixture. Whether to use water or emulsion depends on the fluidity you desire. Thinned only with a liquid emulsion (called "acrylic medium") the paint retains a certain heaviness similar to a light cooking oil. If a more watery mixture is desired, it's necessary to add water, alone or in combination with the emulsion.

Some manufacturers supply an emulsion that's almost as heavy as the paint itself. In this case you would definitely have to add water to achieve a thinner mixture. For really heavy applications of paint, where you want the brush strokes or knife work to hold their form, you can add a medium called modeling or molding paste.

To overcome the loss of binding strength when using excessive water in the final layers of paint, I seal the painting with a layer of clear emulsion or acrylic varnish. These are available in either a glossy finish or a mat finish. For my own work I prefer the mat finish, so the painting may be viewed from any angle without disturbing reflections. However, I do find that a glossy varnish imparts a depth to the colors that may be preferable in some instances.

Since acrylics do not adhere to a non-porous surface, either glass or an enameled surface make ideal palettes. You may squeeze out the paints onto the surface in the manner of oil paints, in amounts sufficient for about an hour's work. Some artists prefer to put each color in a small jar or plastic cup, since they'll stay moist a bit longer, especially if covered. To clean the palette you only have to place it under water for a few minutes and the dried paint can be peeled or lifted from the surface.

Actual size detail from acrylic painting, ISLAND MILL.

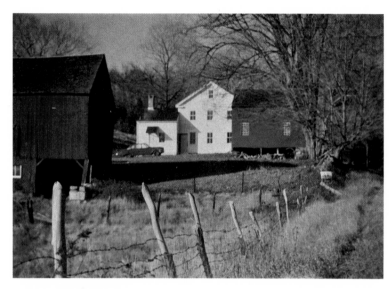

Farm in Bridgewater as
seen by the camera.

Section 5

A step by step oil demonstration

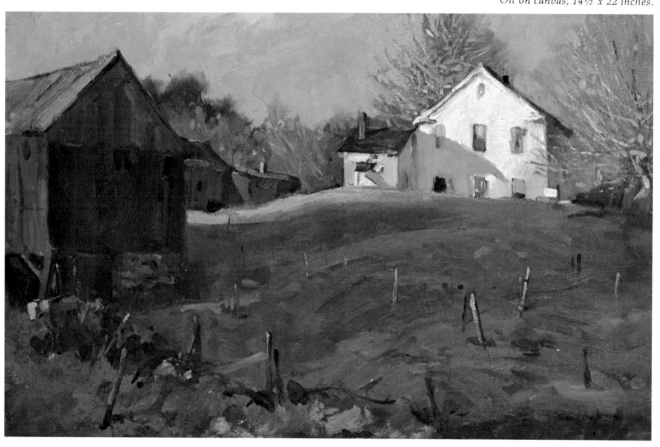

While most of the illustrations in this book deal with the application of paint — the physical materials that one uses to transform mental impressions into visual images — it is important to remind you that these are but the means. First must come the motivation for using them. When you have discovered a subject for your brush, don't be in a great rush to lay on the paint. Relax, walk around, get acquainted with nature. Let the idea emerge from your observations. Decide on a dominant motif. A painting should not merely be a random collection of facts, but a positive statement in which all of the elements serve to strengthen the motif.

Take a long time to think about the composition . . . how much to include . . . the best vantage point from which to observe the subject. Proceed slowly with the placement of these elements, not in terms of accuracy of facts, but as they best express your idea. A painting is not a document of facts, but the artist's vision, stripped of the unessential, and arranged to express the motivating idea of the individual.

In this section I thought it might be of interest to follow the development of the painting shown on the previous page, from concept to finish.

On an afternoon in early November, I came upon a small farm just outside of Bridgewater, Connecticut. While making the quick pencil studies shown on opposite page, I was attracted to the contrast between the old weathered barn, slightly weak at the knees, and the proud farm house sitting on a rise like a guardian of the land and the tired outbuildings. This would be the theme for my painting.

I planned to return the following day with my oil paints, but before leaving I made a number of small composition studies (shown almost actual size on this page) primarily to establish the shape of the painting, so that I could prepare a canvas to that proportion. I should mention here that some artists work with a predetermined shape for the canvas, and design the composition to fit it. Whenever possible I prefer my method.

I did return the next afternoon, and on the following pages I describe the various stages of my procedure for the painting entitled *Proud Farm*, shown on page 61.

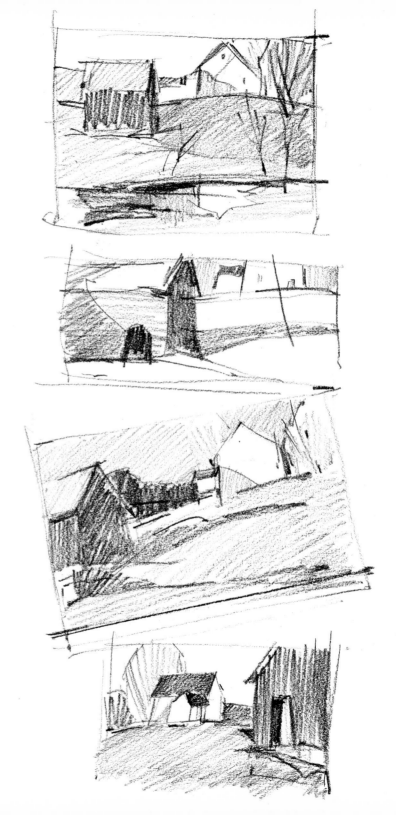

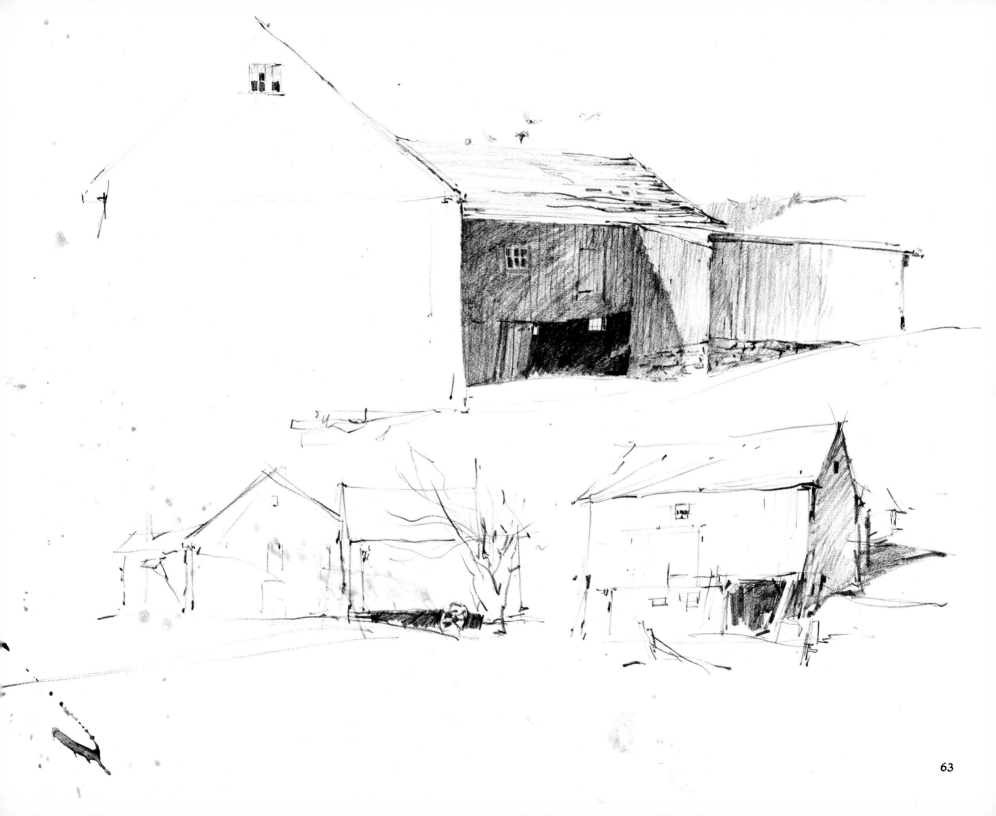

63

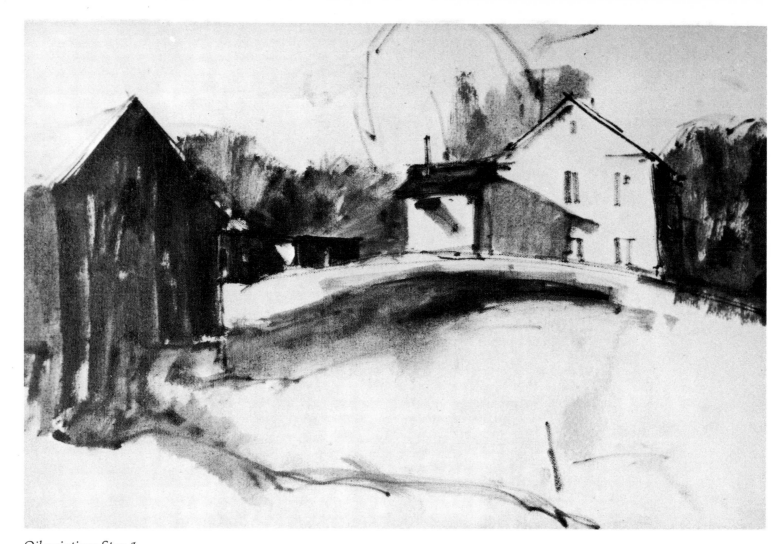

Oil painting: Step 1
I began sketching directly on the white canvas,
using a small flat bristle brush and burnt
umber color to establish the main shapes of
the scene. Sometimes I tone the canvas first;
other times I draw first and then tone around
the drawing, so to speak. Using a fairly dark,
but thin, mixture of burnt umber I quickly
brushed in the major shadows and some other
areas that I envisioned as basically dark
elements: the background trees and roof of the
white house.

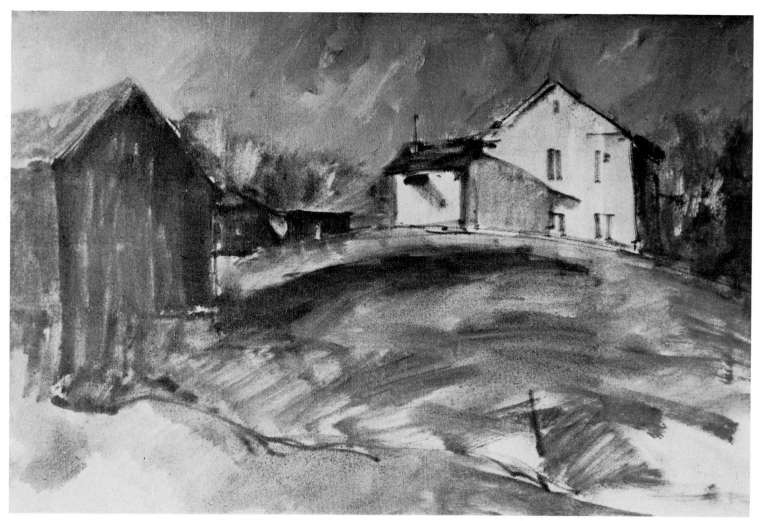

Oil painting: Step 2
I used a lighter (thinner) mixture of burnt umber
to quickly tone those areas representing middle
values of the subject. Then a still lighter tone
was used for the lightest area of all, the house.
This method of toning allows me to feel out
forms such as the contour of the hillside, even
at this early stage. Now ready for the next
stage of painting, I put in the sky with what I
hoped would be an approximate color and value.

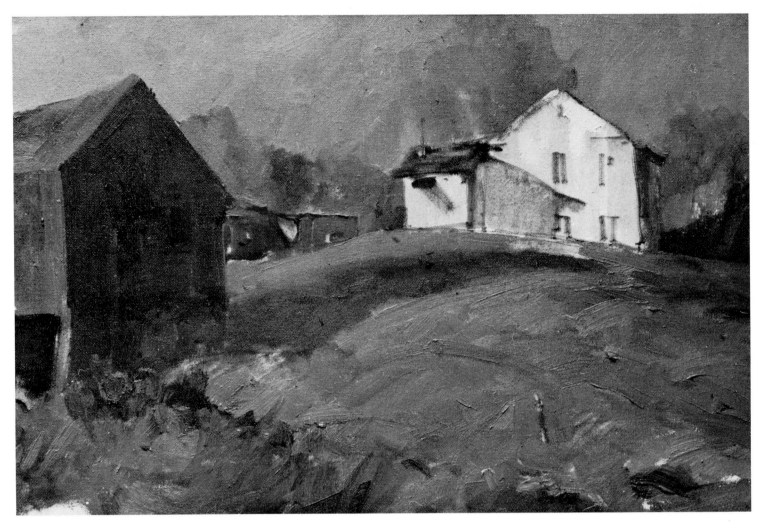

Oil painting: Step 3
I moved down through the painting, broadly
establishing the major areas with a more buttery
consistency of paint. At this point I felt it
wasn't necessary to touch the house, other than
to put in a single stroke of the lightest value
so I can relate other tones to it. I continually
moved back and forth from area to area at
this stage.

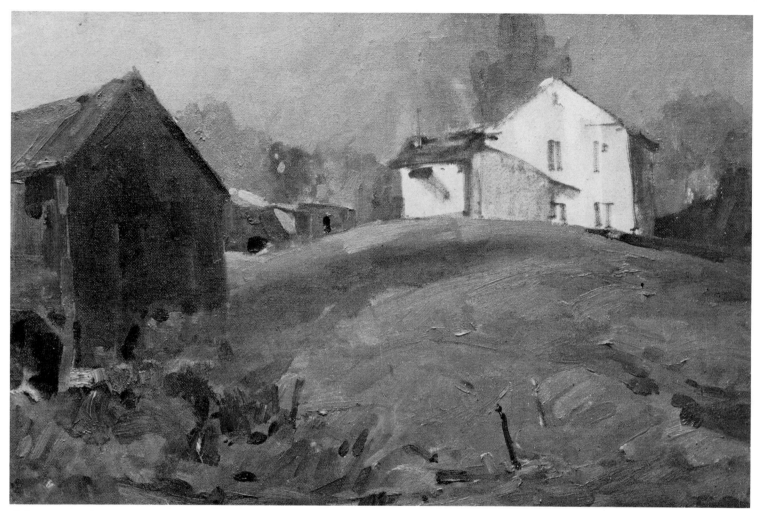

Oil painting: Step 4
At this point I considered the sky too dark,
so I lightened it a bit. Back and forth over the
entire landscape I kept making adjustments in
color and value. I also began to develop some
of the smaller shapes along the fence line in the
lower left corner.

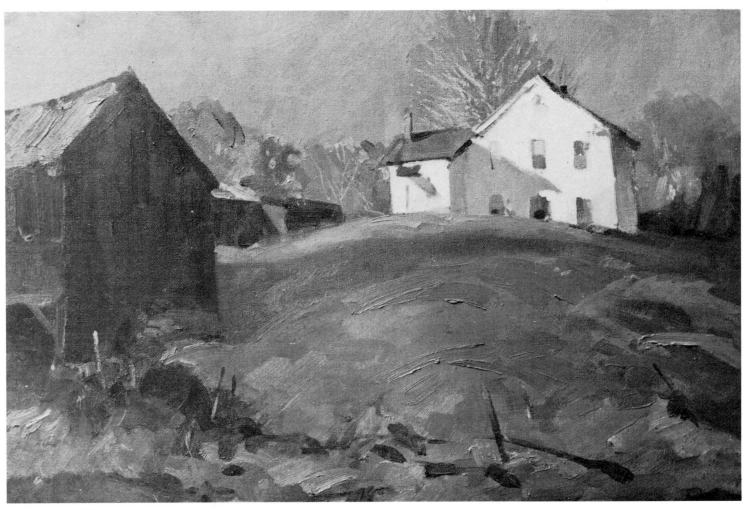

Oil painting: Step 5
Further adjustments of each area continued, and
I became more concerned with the character
of the brushwork in terms of expressing both
form and texture. The thick and thin quality of
the paint was now more apparent as I neared
the final stage. I now developed both the
light and shadow planes of the white building.
Unfortunately, I wasn't at all pleased with
the character of the hillside at this point.

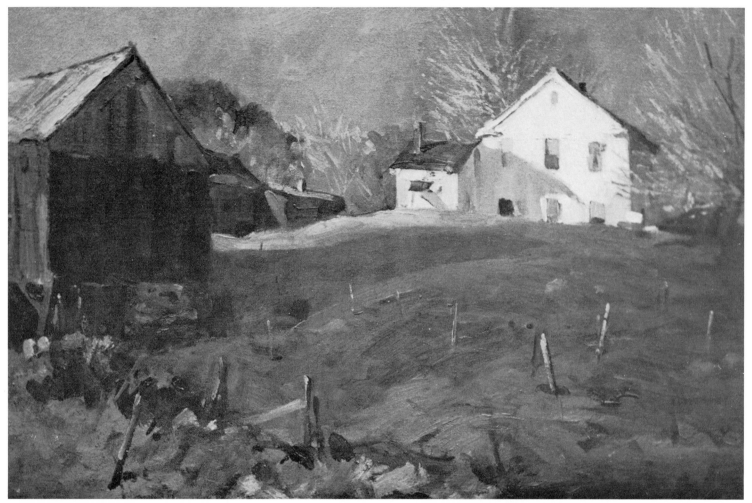

Oil painting: Step 6
I completelty re-started the ground, including the fence line, and made further adjustments in the barn. I cut down the height of the wing on the white house and now, satisfied with the overall impression, proceeded with the subtle refinements and details that would complete the painting.

Final painting: Shown in color on page 61. After studying the painting at home in the studio, I decided to further lighten the sky. Although I had intentionally used a very dark sky in the painting, it now seemed that a lighter one would dramatize the effect of the light better and provide a more interesting light and dark pattern of the overall painting. I also strengthened the light on the two large trees.

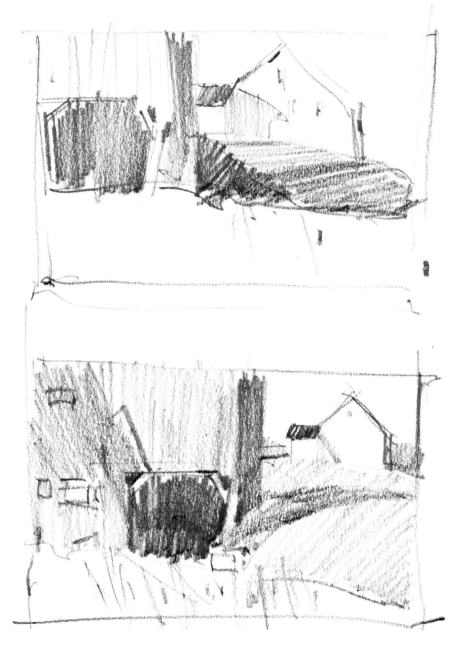

Composition studies for my watercolor.

Section 6

A step by step watercolor demonstration

When the oil painting shown in the preceeding section was completed, I prepared to do a watercolor of the same subject for the purpose of using it in this book as a comparison of my painting methods in the different mediums.

I returned to the farm in Bridgewater for a fresh look at the subject, so I might visualize it in terms of new painting rather than just a copy of the existing oil. In this respect you'll find that I've made some adjustments in the composition. My interest was now drawn to the variety of textures down behind the barn. I decided to make the barn and the tall grasses the more dominant features, with less emphasis on the house. In other words, my motivation for the painting had changed, and so the design had changed as well.

For this step-by-step demonstration I've used a medium rough paper and mounted it dry to the drawing board with one inch masking tape and a half-dozen thumbtacks. The painting was done with three brushes: a three-quarter-inch flat sable, a #9 Winsor and Newton round sable and a #6 Grumbacher round sable.

This watercolor was done in my studio, since I felt sufficiently acquainted with the subject, and also because I wanted to photograph the various stages while in the very process of painting.

My choice of colors for this painting was similar to those used for the oil painting. It consisted of burnt umber, yellow ochre, Hooker's green (in place of virdian used in the oil painting), burnt sienna, cerulean blue and alizarin crimson. My oil palette had also included cadmium orange and cadmium red light.

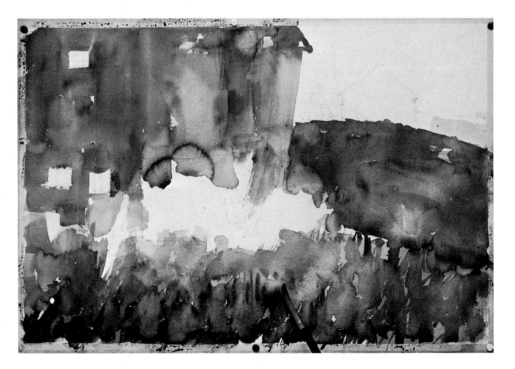

Watercolor painting: Step 1
After lightly sketching the main shapes of the scene, using my small composition study as a guide, I prepared a medium dark mixture of alizarin crimson and burnt umber. This color was applied to the barn by using a large flat brush. Note that I painted around the windows since I intend to keep them lighter than the barn, but I let the color lap down into the area under the barn, since this will be darker in the final painting. You can see from this photo that the color is quite wet.

Watercolor painting: Step 2
Without waiting for the previous color to dry, I prepared a neutralized green mixture and painted in the grass area to the right of the barn. Then a mixture of burnt umber and yellow ochre was used for the foreground. This was all done with my #9 sable. I went back over the foreground a number of times while it was drying to get some tonal variations. Then I used the smaller round sable to put in some vertical strokes to begin developing the texture of the tall grass.

Watercolor painting: Step 3
The barn was relatively dry at this point, so I again used the red-brown mixture to darken the left side and to apply some drybrush tones in the center area to suggest the vertical barn siding. Next I developed more vertical strokes in the foreground grass. Then the dark green cast shadow was laid in across the field. Finally the shadow end of the barn was put in. The photo shows my lifting out some of the wet color to lighten the shadow in the lower area.

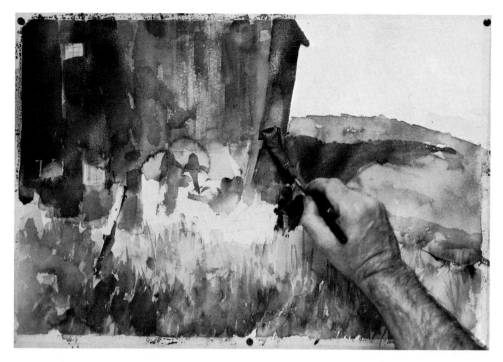

Watercolor painting: Step 4
At this stage I put in a very pale tone for the sky, just dark enough to separate it from the white house. While this was still wet I added the dark stroke to the right of the house, producing a blending of the color where the two washes met, which would help suggest that this area was in the distance. Next I put in the darkest color for the area under the barn. In the photo I'm using the smaller brush to produce a jagged edge and some tonal variations where the grass meets the dark interior. The overall tonal plan of the painting is now established, and I'm ready to put in the details.

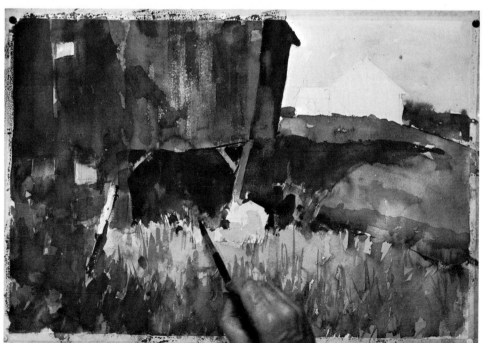

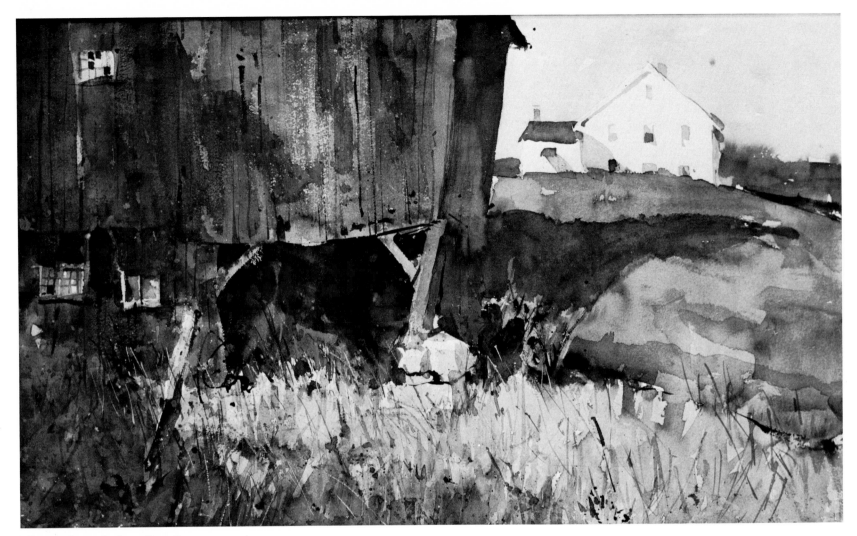

Watercolor painting: Step 5
Here I've added the details of the house,
handling them very simply in order to suggest
that this area is some distance away. I have also
developed the windows of the barn, the
indication of cracks in the barn siding and more
grass textures. At this point I placed a mat
around the painting in order to get a better
impression of the overall effect. Now I feel that
I should add a little more textural quality to
the foreground, and I find that the lower right
side of the painting needs to be strengthened in
some way.

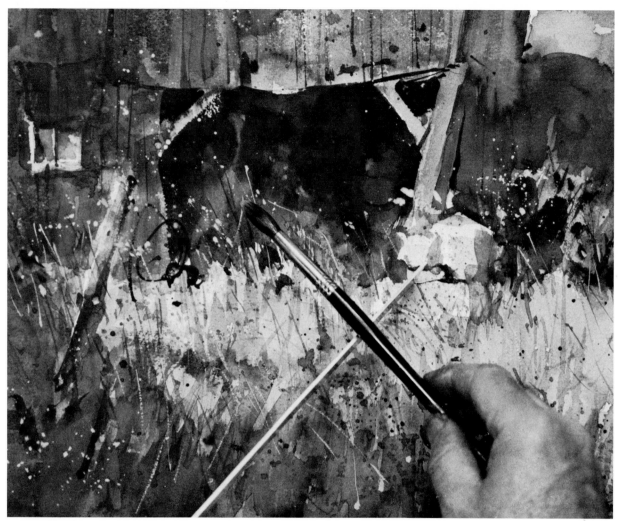

Watercolor painting: Step 6
For greater textural variety in the foreground
I applied some spatterwork. Darker spatter was
used in the lighter areas of the grass and light
opaque spatter is applied to the darker areas.
The lighter spots extend up into the barn itself
to further the impression of the rough character
of the building. In the photo I'm striking the
edge of a steel ruler with the handle of the brush
to produce the spatter.

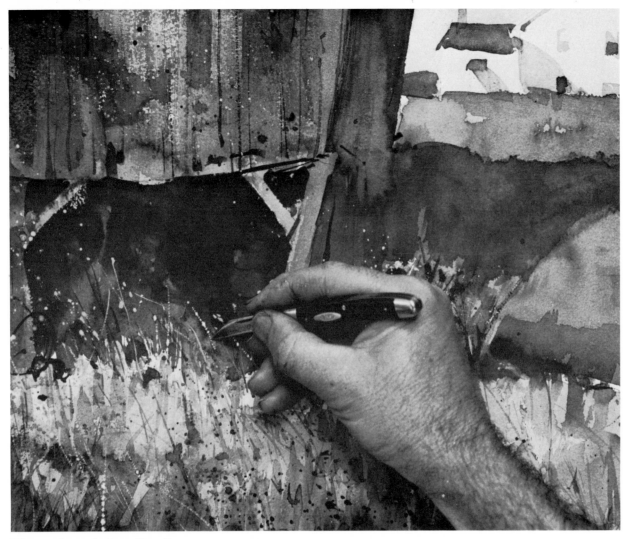

Watercolor painting: Step 7
This photo shows the use of the knife to scrape light lines through the dried paint. In this case I used it in a number of places to indicate stalks of grass. I had already added some light lines by using opaque paint, but I wanted to get more variation in the character of these linear strokes.

Finished painting (on opposite page)
In the final stage of the painting I added the fence posts in the lower right area. This, I felt, created a better balance for the larger forms and the more active painting on the left.

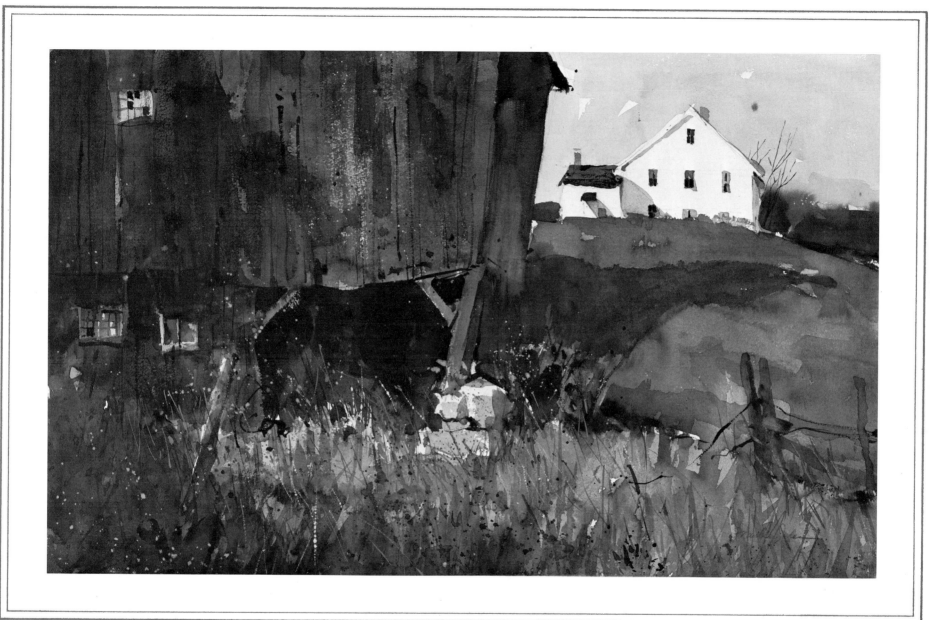

THE BARN
Watercolor, 14 x 24 inches

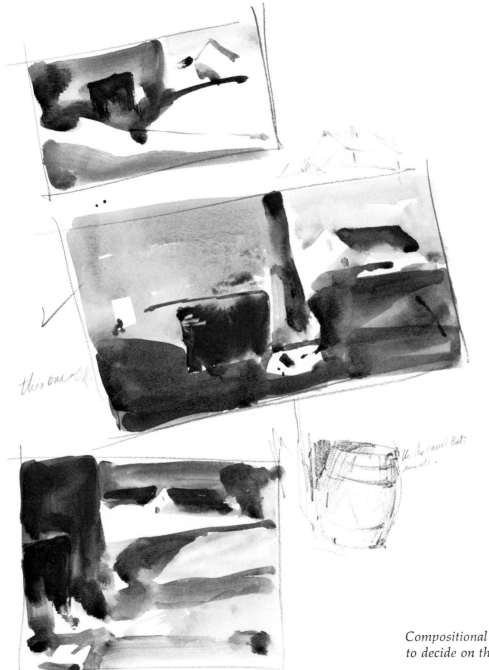

Section 7

Compositional doodles in raw umber help me
to decide on the basic pattern of values.

A step by step acrylic demonstration

Whether or not I needed a third painting for this book, I would have tackled this same subject with acrylics. As I became more familiar with the scene, seeing it in the fading afternoon light, feeling the coolness of deepening shadows in the late fall and sensing the warmth that saturated the crest of the hill just before the sun dropped out of sight, I felt the acrylic medium would allow me to best capture my impression.

As I concerned myself with the composition, the upward thrust of the house became less important. I decided to let it drop behind the hill as though fading away with the light itself. I also turned the house to create a more interesting variety of shapes and to increase the sense of depth in this area.

The active textures of the foreground grass would be subdued to place more emphasis on the quiet peacefulness of the setting.

Since I planned to work quite small, I chose a commercially prepared acrylic board. This has a white acrylic surface on a heavy cardboard. The size of the board was 16 x 20 inches, so I cut it down to fit the shape I had arrived at in my composition studies — 12 x 20 inches.

My choice of colors was as follows: burnt umber, yellow ochre light, napthol red light, Hooker's green, cerulean blue and titanium white. (This is the same as my watercolor palette, except that alizarin crimson is not used as an acrylic pigment, and so I used one of the acrylic reds.)

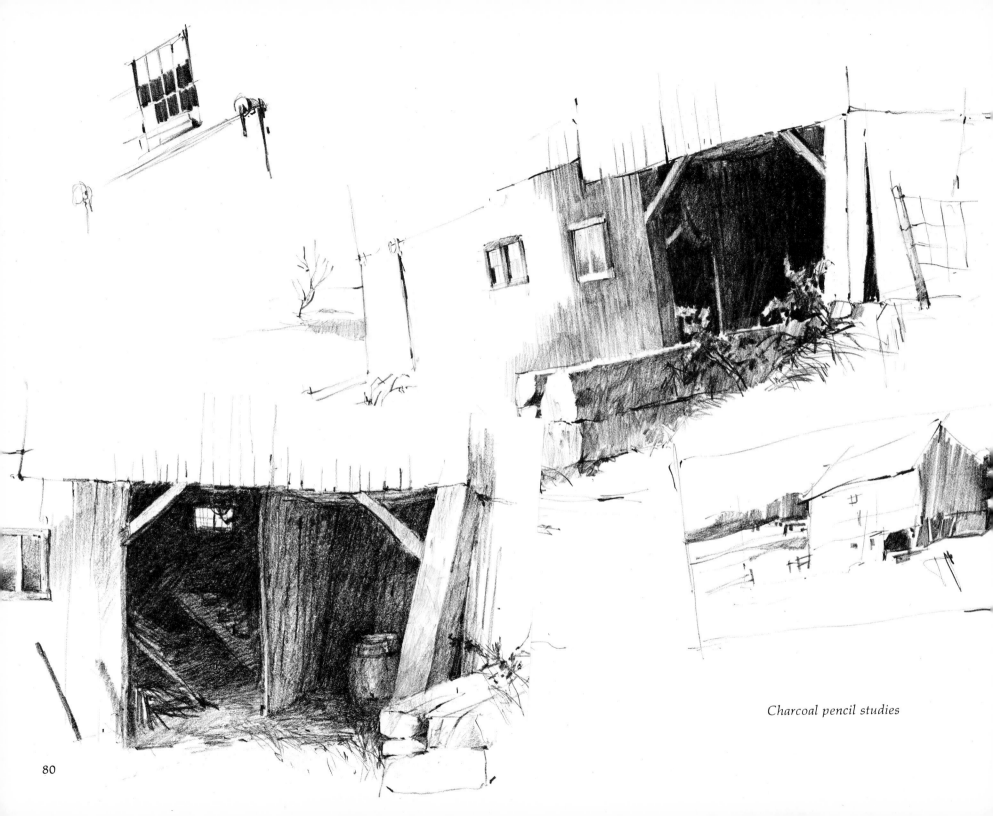

Charcoal pencil studies

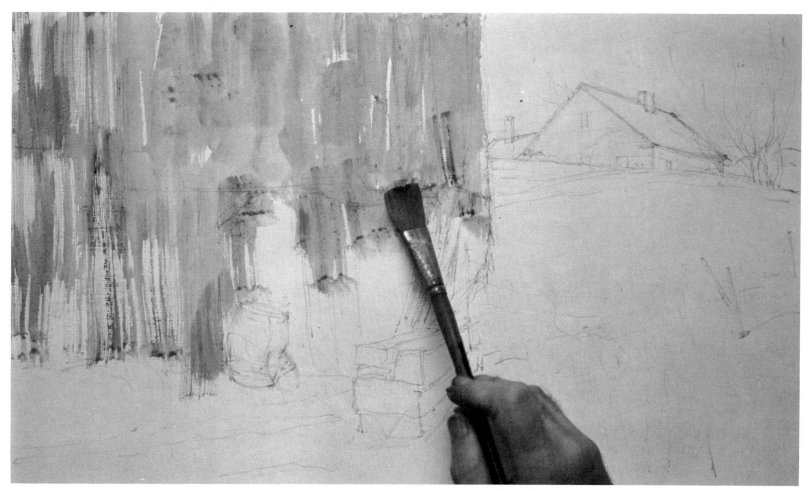

Acrylic painting: Step 1
Using my previous paintings, charcoal studies,
and small wash composition study as a guide,
I sketched the scene on the acrylic board using
pencil, I then proceeded boldly to wash in the
barn with vertical brush strokes, using a varied
mixture of yellow ochre and Hooker's green.
I paint right over such areas as the window
and opening under the barn at this point.

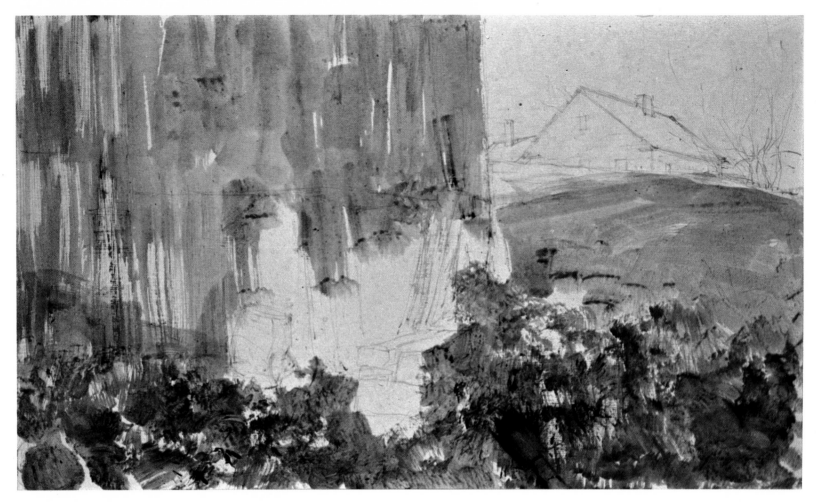

Acrylic painting: Step 2
I quickly moved on to establish an undertone for
the distant grass and then the foreground,
using a fairly dry brush with thin color. Then
I switched to a bamboo brush for some textural
indications in the foreground. Because the
brush was quite dry, with paint only on the very
tip, the hairs separated as shown in the
photograph. I used these to lightly stroke and
jab the surface to produce a variety of lines.

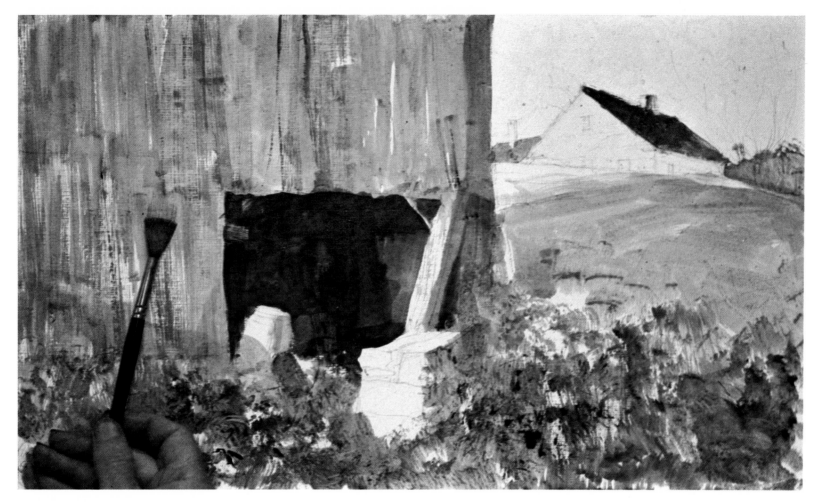

Acrylic painting: Step 3
With the middle tones roughly indicated, I moved
on to establish the darkest areas: the roof of
the house and the interior of the barn. This
enabled me to roughly get an idea of the tonal
pattern of the overall painting, and I could now
use the darkest values as a guide for the
lightness or darkness of other areas. I used
the split-hair technique next to indicate lightly
the vertical grain of the barn siding.

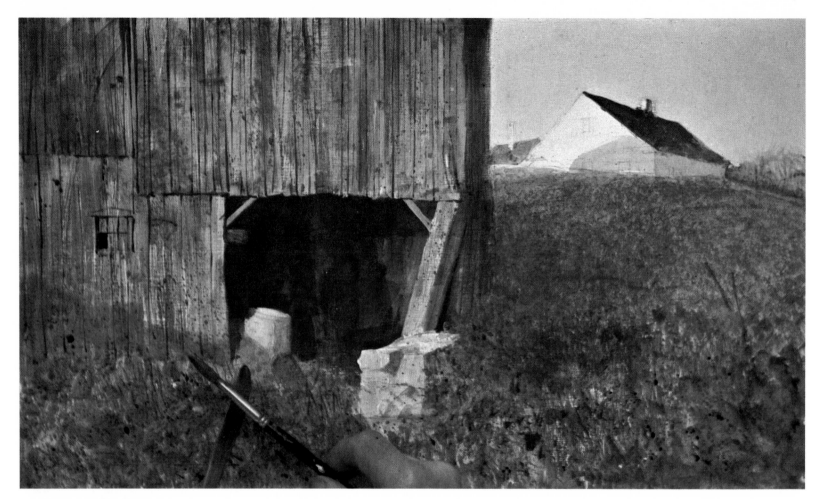

Acrylic painting: Step 4
I next developed the distant grass area by
repeatedly jabbing the surface wth the tip of the
bamboo brush until I had achieved the degree
of darkness I wanted. Then I applied a pale
yellow, opaque mixture over the sky and put in
the soft shadow on the house. Textures and
lines were added to the face of the barn, and I
refined the area around the opening. The
foreground grass was darkened and I added
some spatterwork in this area and on the barn.

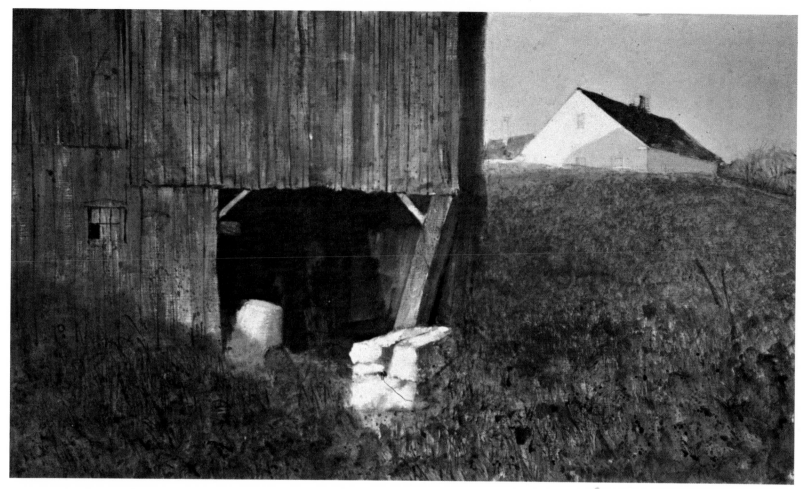

Acrylic painting: Step 5
With the texture of the barn siding just about
complete, I now added varying tones of red, both
for color and to establish the proper darkness.
The left foreground was darkened. A transparent
yellow tone subtlely darkened the sky. At this
point I used pure white to clean up the light
area of the house and the barrel under the barn.
Then I dragged white paint over the blocks
of granite as the first stage of creating a rough
stucco-like texture.

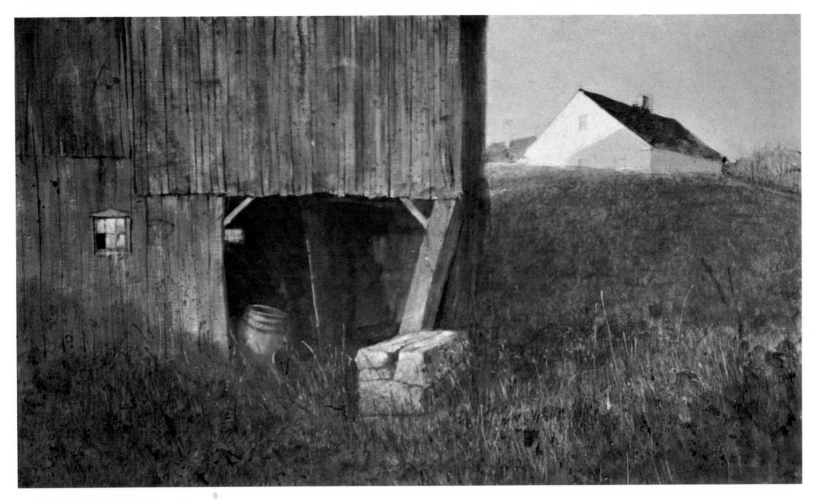

Acrylic painting: Step 6
I now refined the subtle details of the granite
blocks, the barrel and window in the barn.
Opaque white was used for the thin strokes in
the grass and for some spatterwork.

Acrylic painting: Final stage
In the finshed painting (opposite page) I've
completed the house, added the tree and softened
the shadow side of the barn against the sky.
Finally, to unify the color in terms of the warm
light, I added a pale yellow wash to the sunlit
areas of the painting.

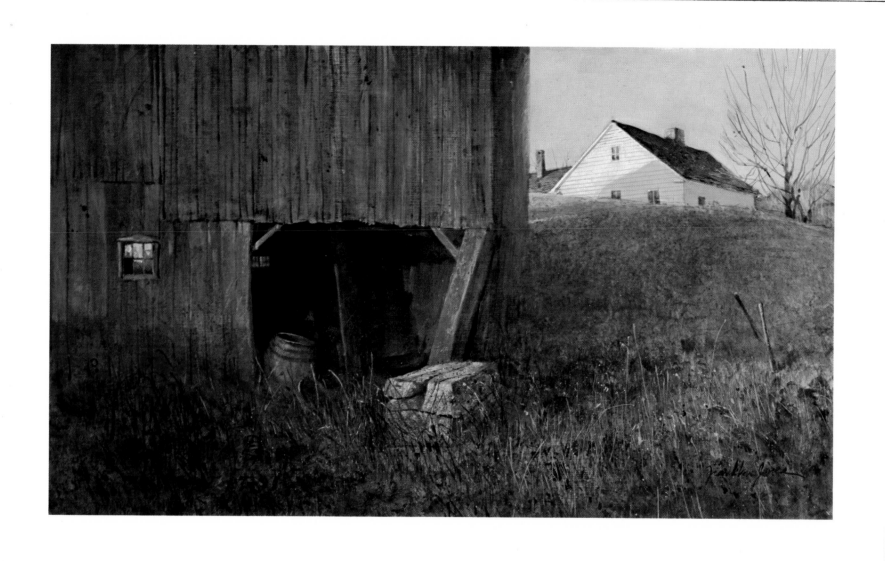

CENTENARIAN
Acrylic, 12 x 20 inches

Section 8

Portfolio

On the following pages of this section are examples of paintings done with each of the three mediums. Usually my purpose in developing more than one painting of the same subject is a search to intensify my reaction to it, to be more selective in the treatment of the elements. Sometimes, as I become more involved with the environment, my affection for it is heightened, and I feel the need to make a more personal contribution to the statement. Perhaps my abilities with another medium will allow me to say it more clearly. (I blame the medium for my own inabilities.)

The concept as well as the medium may change in some instances as I start over. This is particularly evident in the first two versions of the stone wall (pages 95 and 96). At other times the differences are subtle as in the same subject on pages 96 and 97.

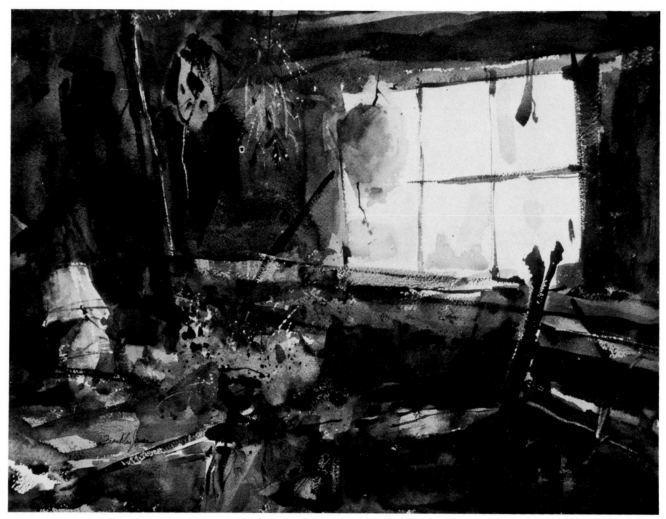

Preliminary study for WASPS' NEST
Watercolor, 17 x 23 inches

▷
THE HERB BARN
Oil, 14 x 18 inches

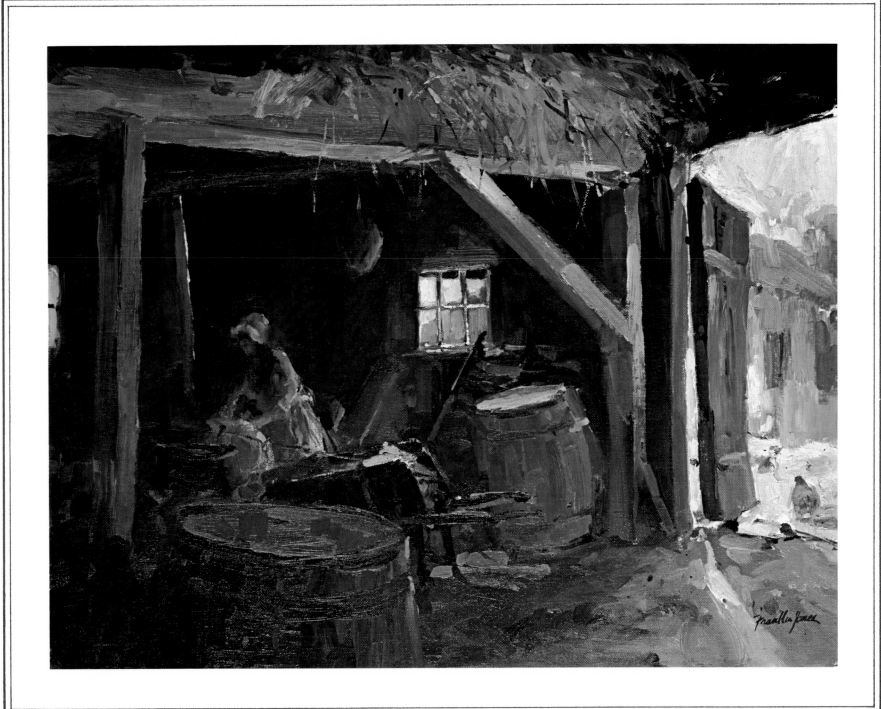

WASPS' NEST ▷
Acrylic, 20 x 36 inches

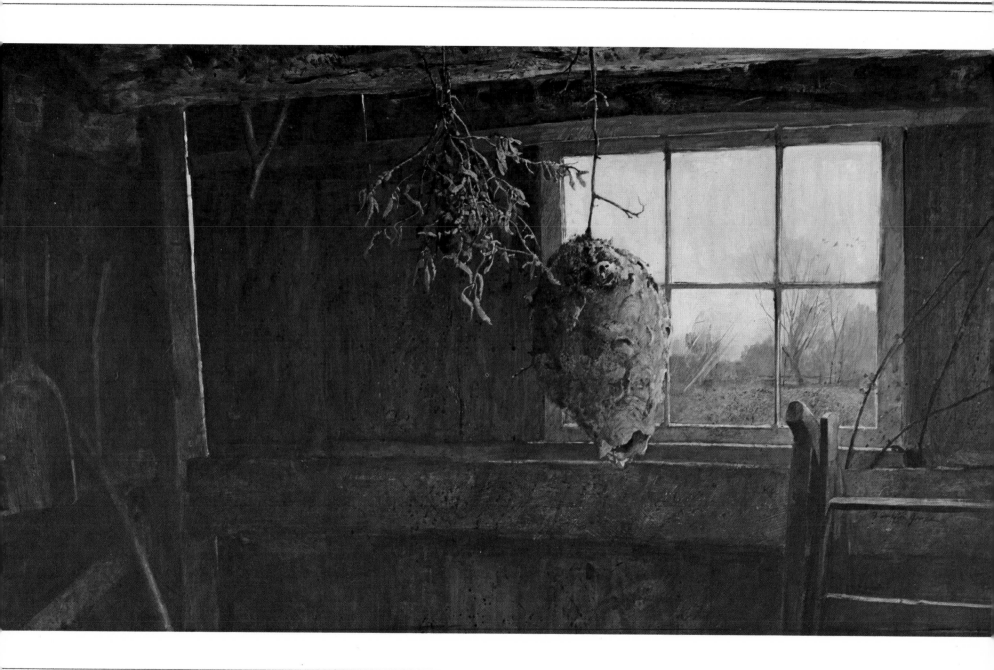

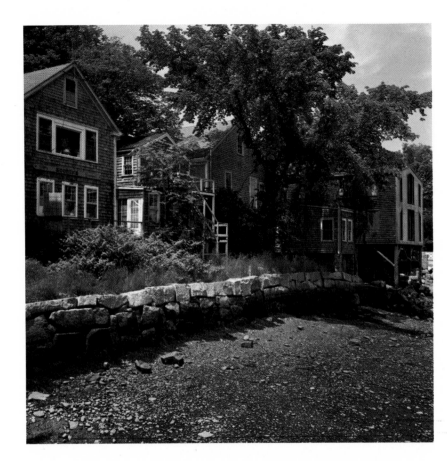

The artist translates what he sees to a personal level. This is evident in the next three paintings based upon this scene along the edge of the harbor in Rockport, Massachusetts.

▷
HARBOR'S EDGE
Oil, 16 x 20 inches

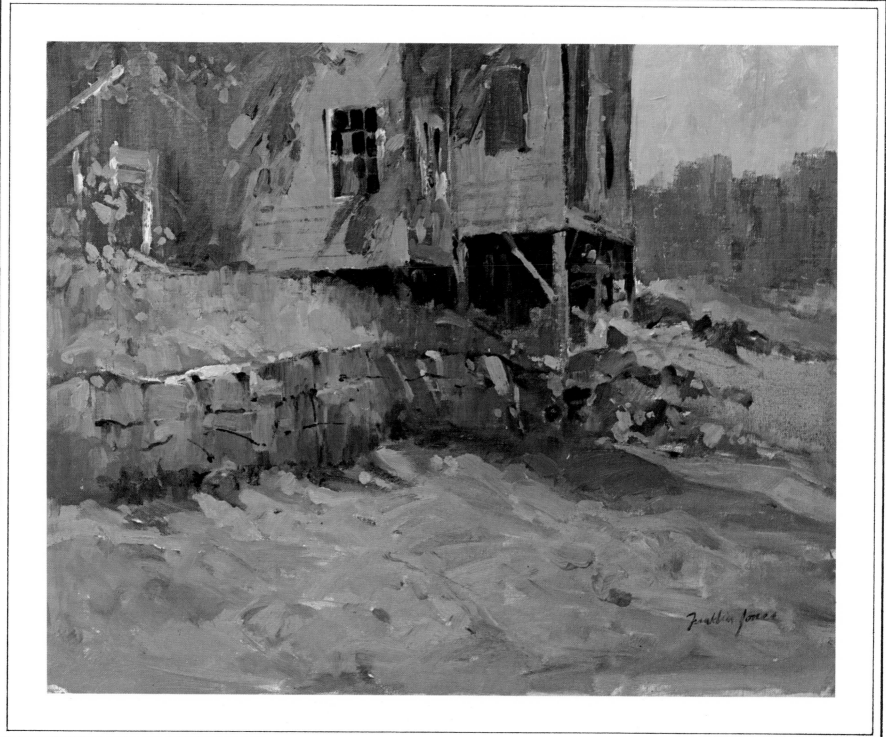

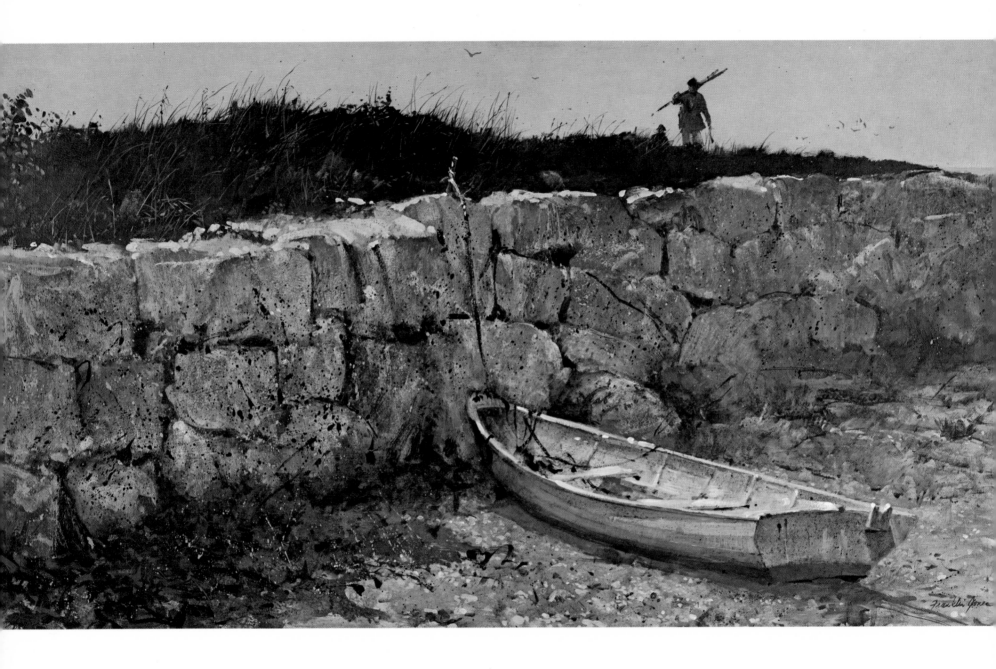

THE SEA WALL
Acrylic, 19½ x 36 inches
◁

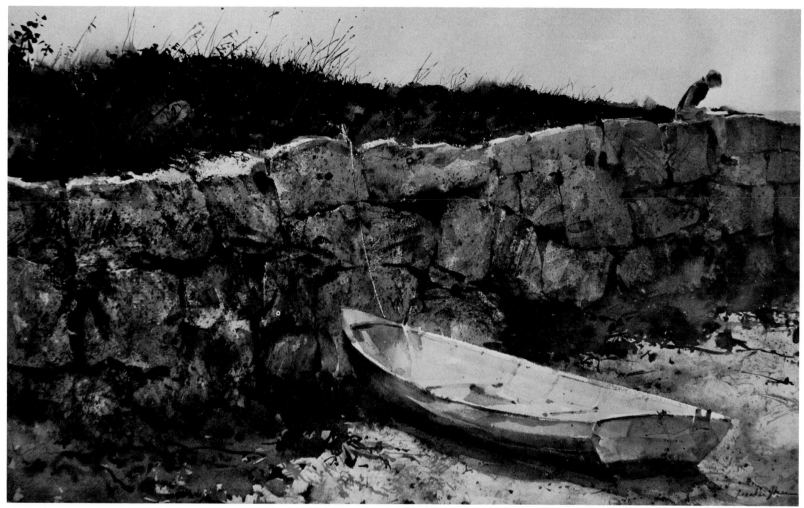

LOW TIDE
Preliminary study for THE SEA WALL
Watercolor, 20 x 32 inches
Owned by Mr. and Mrs. Robert Roth

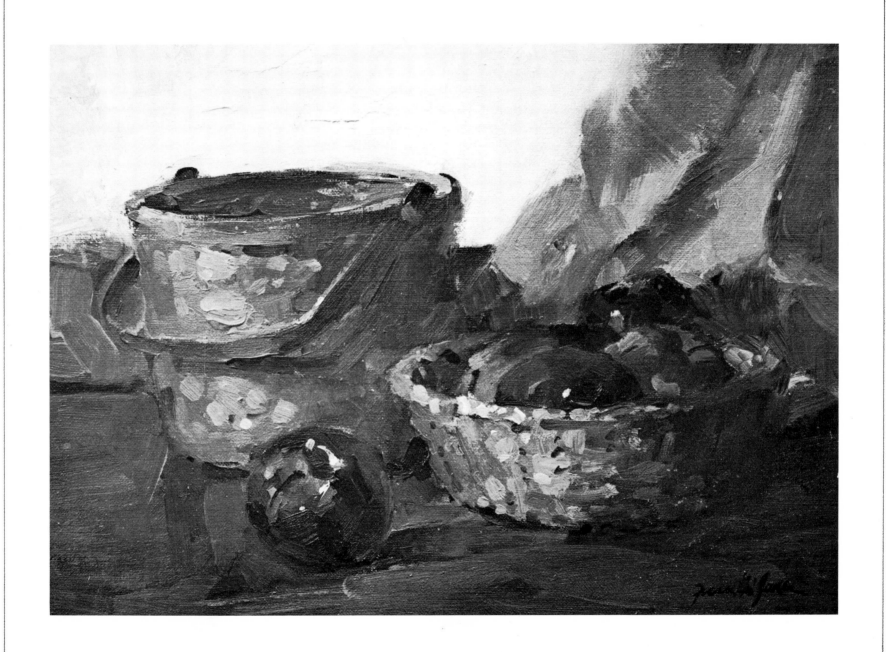

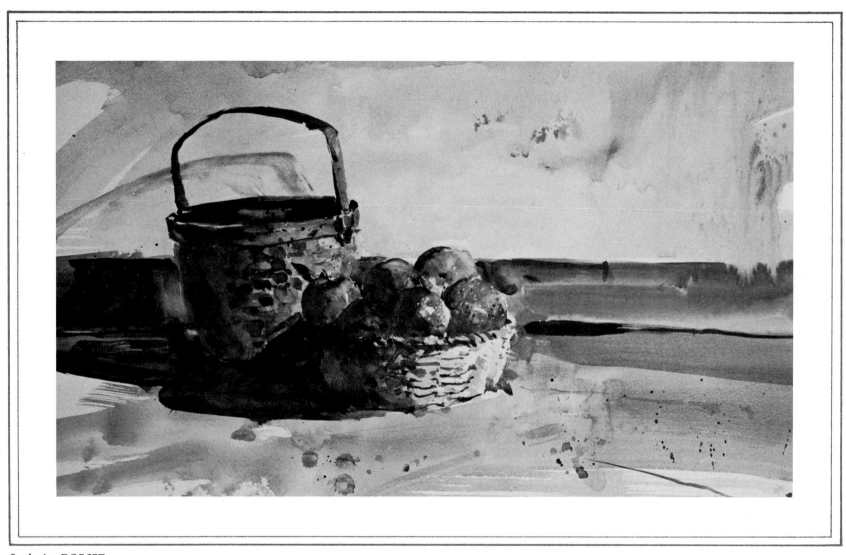

Study for DORSET
Watercolor, 19 x 29 inches

DORSET ▷
Acrylic, 18 x 24 inches

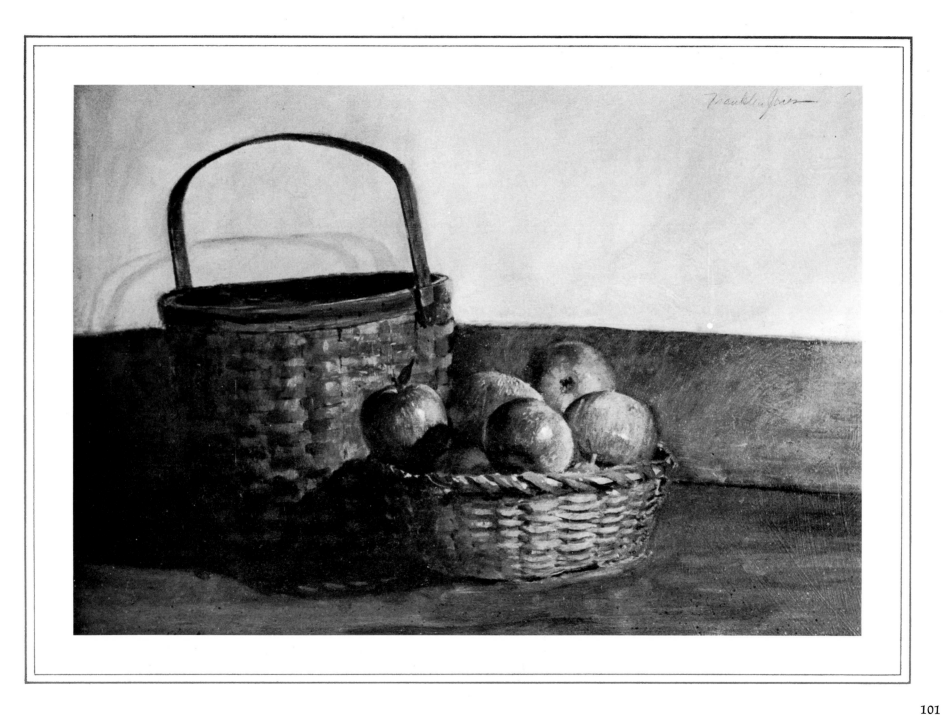

Section 9

THE THRUSH
Acrylic on masonite, 9 x 12 inches

This is a collage. The thrush was painted directly on Masonite and then the pencil drawings, on paper, were mounted to the painting with acrylic medium.

Potpourri

When asked what type of subject I like to paint I usually answer quite emphatically, "landscapes." But this may include an old sap bucket, the interior of a kitchen, a seascape or a small bird dropped proudly at my feet by my well-meaning cat. Subject matter is endless, limited only by my own interest.

I don't select a subject because it's beautiful in the sense of being pretty. The beauty for me is in the feeling that I have for the place or object. I try to achieve a sense of beauty through the arrangement of shapes, values and color. When I've completed a painting I'm pleased, if in looking at it I see not picturesque objects, but sense that I'm in that place, aware of the quietness, hearing the cry of a gull, smelling the sweet odor of hay or feeling the cold bite of the wind on my face. I am successful when the viewer shares my reaction.

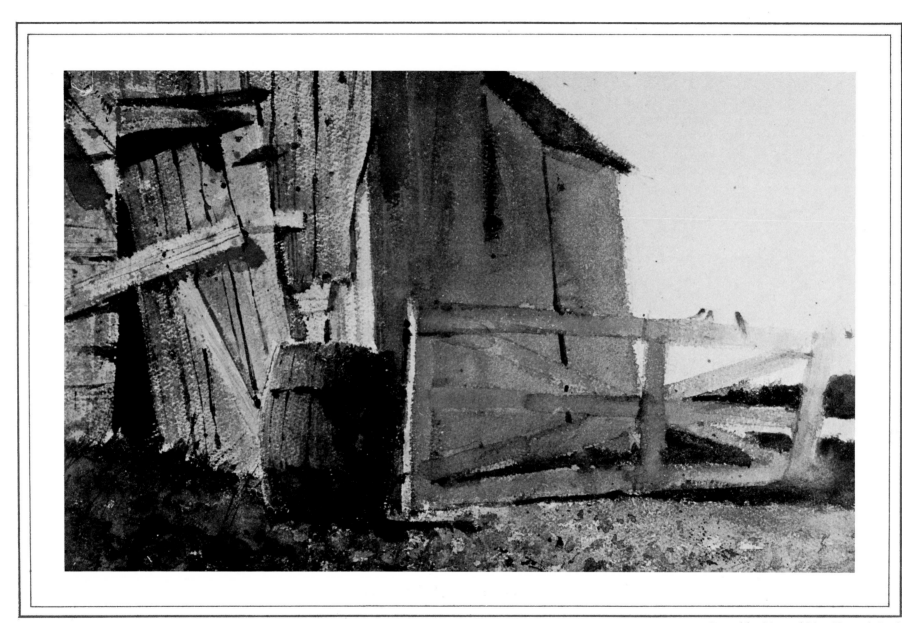

BARN SWALLOWS
Watercolor, 9 x 13½ inches
A small watercolor that later served as a compositional arrangement for ON THE FLYWAY

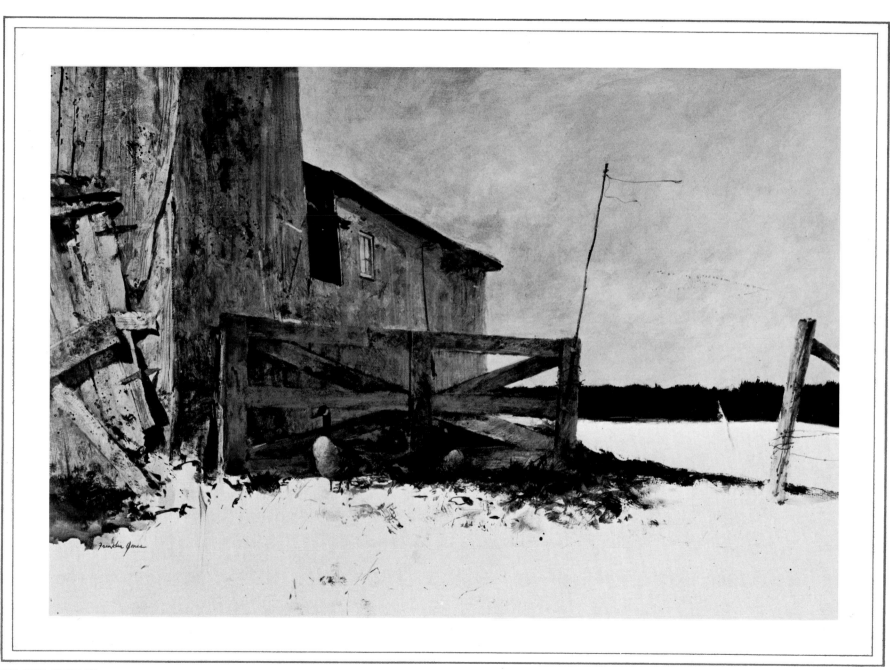

ON THE FLYWAY
Acrylic, 20 x 30 inches

105

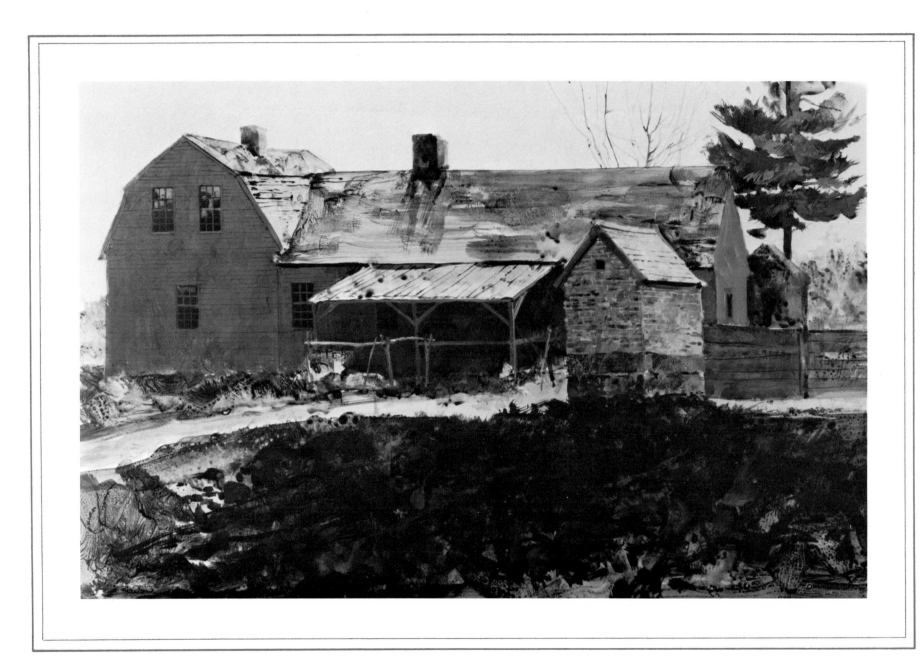

FREEMAN'S FARM
Acrylic, 15½ x 24¾ inches
Painted on a very smooth two-ply plate Bristol paper.

THE MILL
Acrylic, 17 x 29 inches
Painted on watercolor board

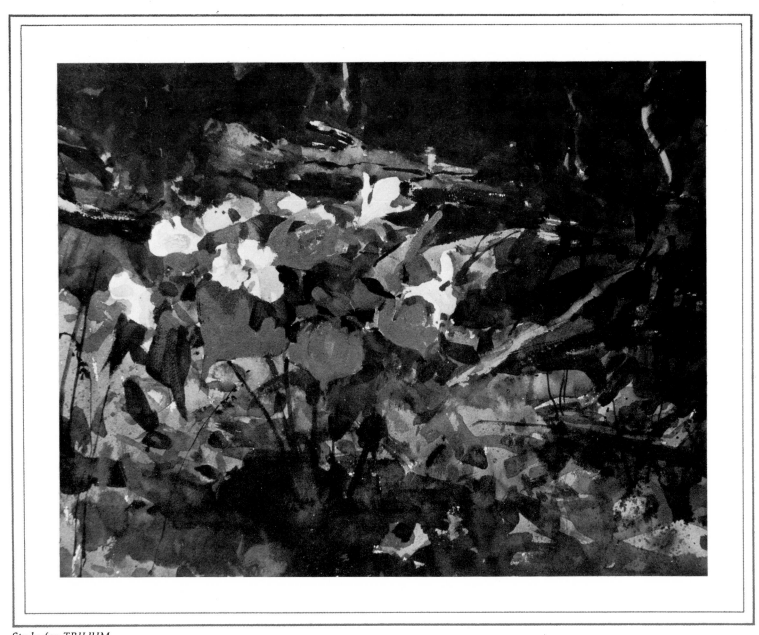

Study for TRILIUM
Watercolor and acrylic on watercolor paper, 19 x 27 inches

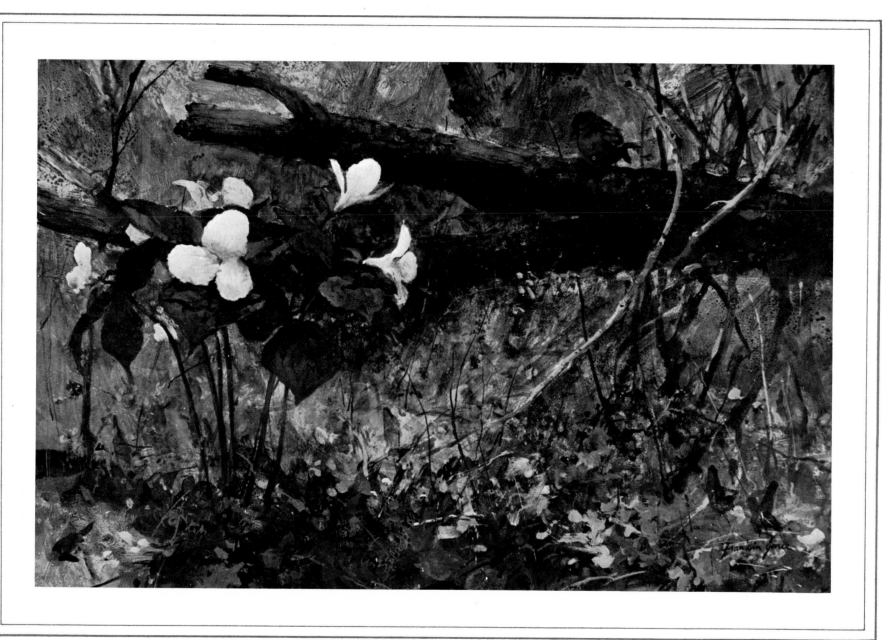

TRILIUM
Acrylic, 24 x 36 inches
Owned by the Connecticut Audubon Society

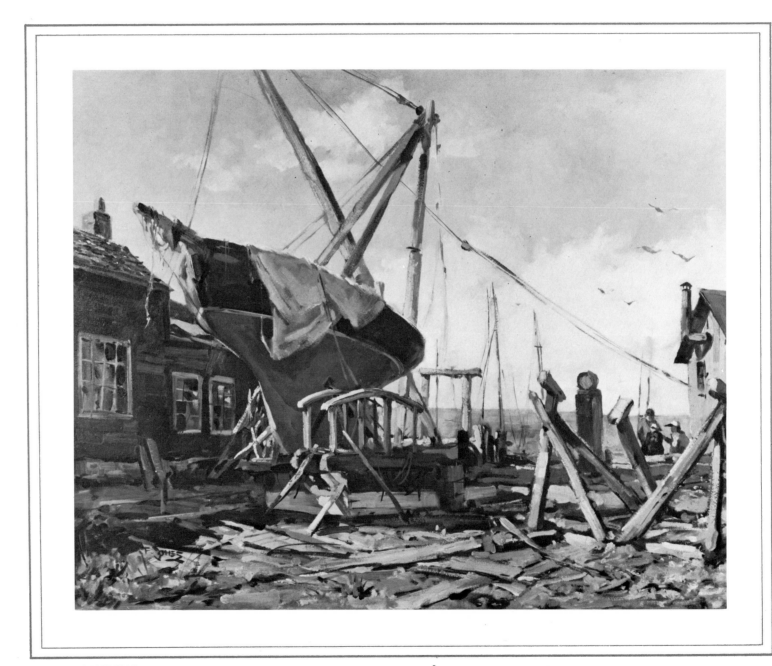

SUNDAY MORNING
Oil on masonite, 24 x 30 inches
Owned by Mr. and Mrs. Phillip Sousa

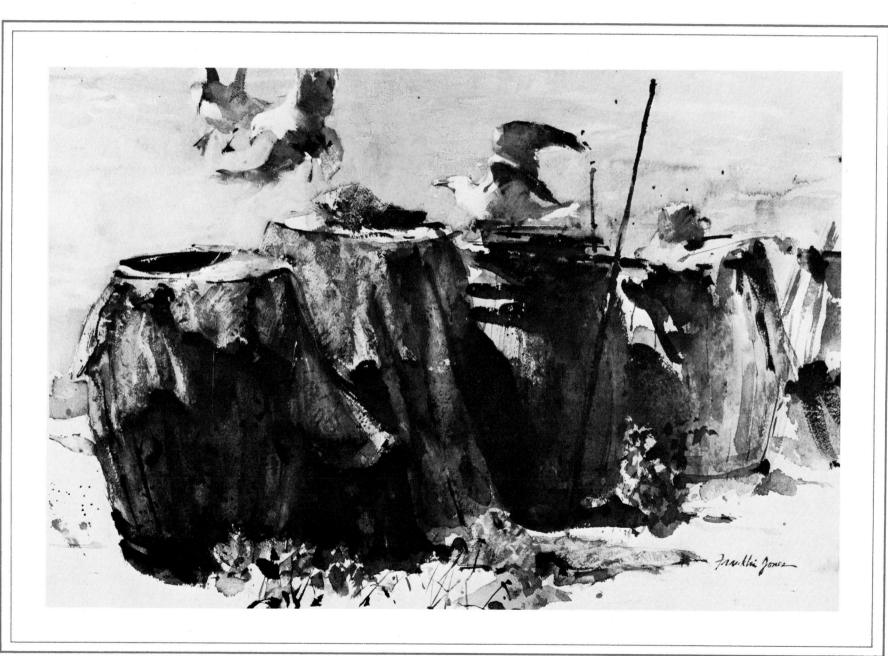

LOBSTER BAIT
Watercolor and acrylic, 17 x 25 inches
On watercolor paper

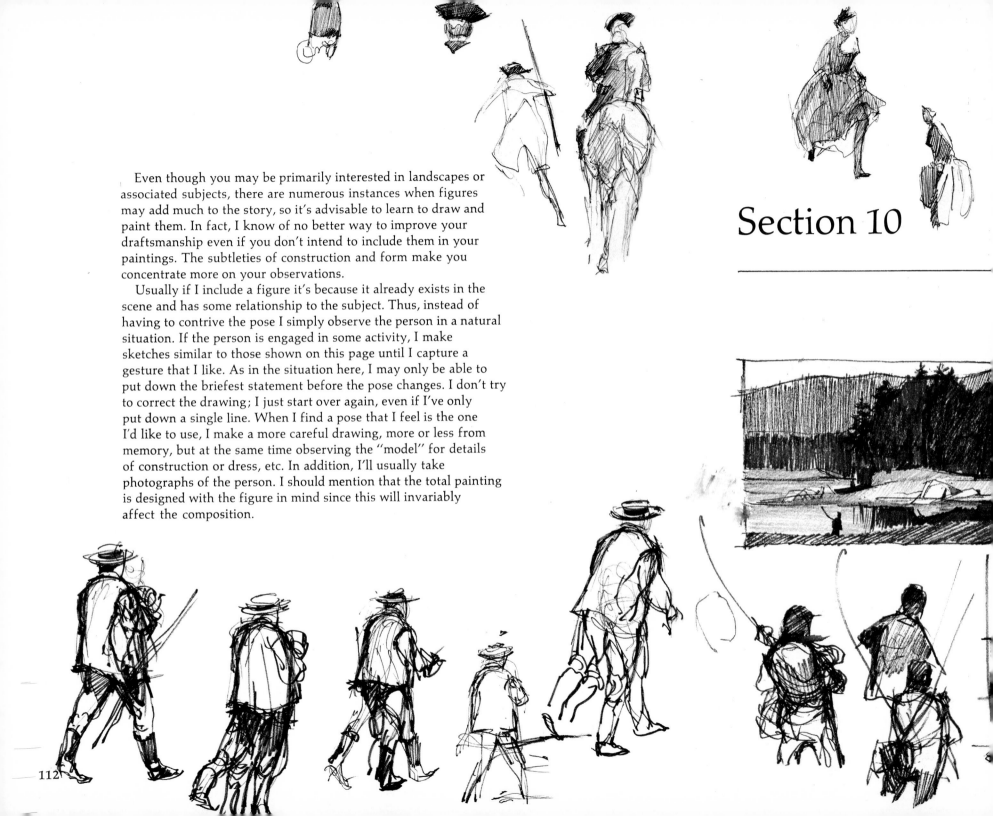

Even though you may be primarily interested in landscapes or associated subjects, there are numerous instances when figures may add much to the story, so it's advisable to learn to draw and paint them. In fact, I know of no better way to improve your draftsmanship even if you don't intend to include them in your paintings. The subtleties of construction and form make you concentrate more on your observations.

Usually if I include a figure it's because it already exists in the scene and has some relationship to the subject. Thus, instead of having to contrive the pose I simply observe the person in a natural situation. If the person is engaged in some activity, I make sketches similar to those shown on this page until I capture a gesture that I like. As in the situation here, I may only be able to put down the briefest statement before the pose changes. I don't try to correct the drawing; I just start over again, even if I've only put down a single line. When I find a pose that I feel is the one I'd like to use, I make a more careful drawing, more or less from memory, but at the same time observing the "model" for details of construction or dress, etc. In addition, I'll usually take photographs of the person. I should mention that the total painting is designed with the figure in mind since this will invariably affect the composition.

Section 10

Hold still please

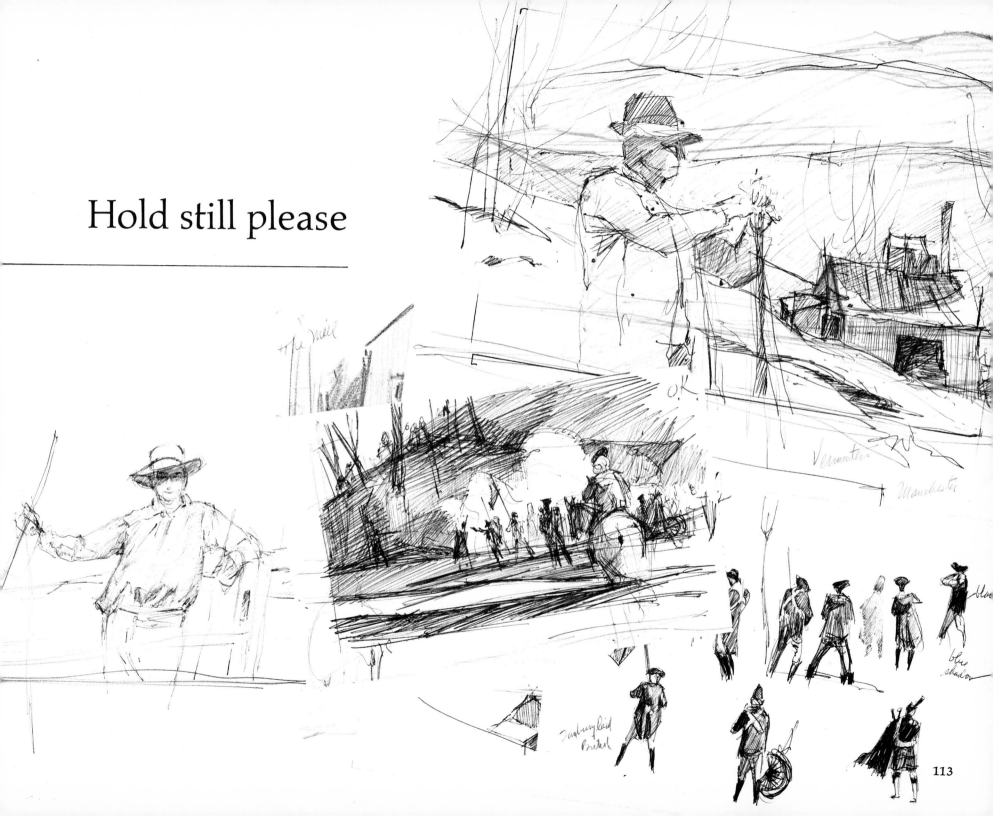

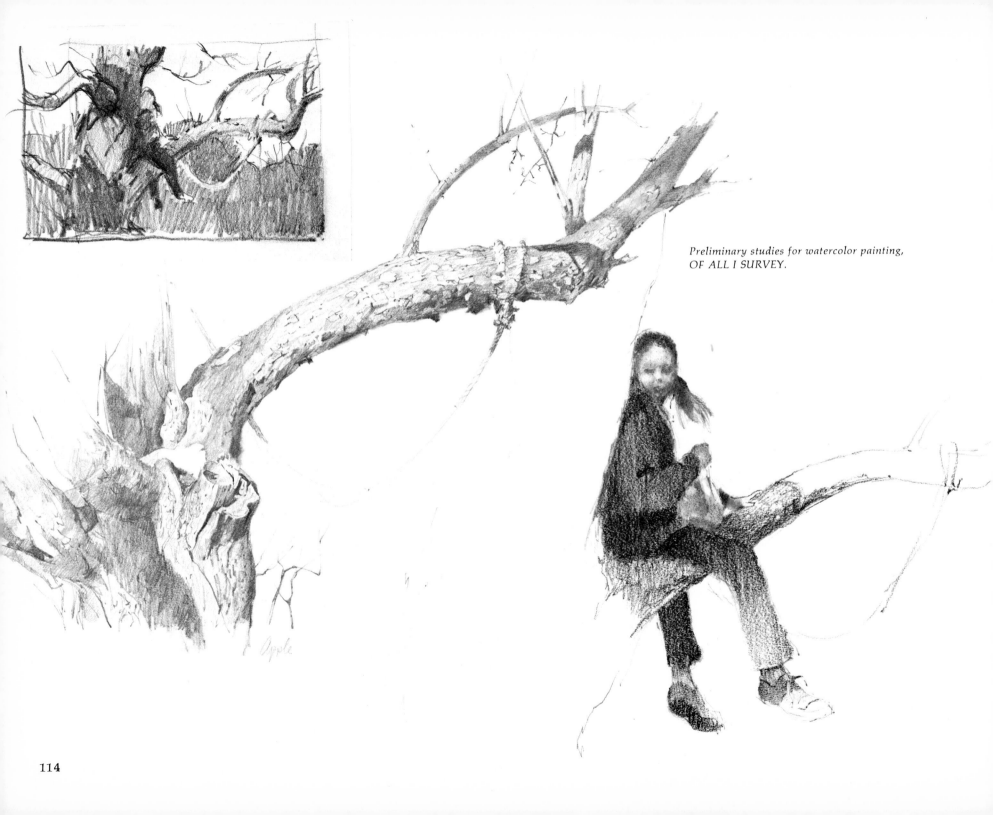

Preliminary studies for watercolor painting,
OF ALL I SURVEY.

In some instances the figure is the motivation for the painting, as in the watercolor on page 116 entitled, *Of All I Survey*. I was on a trip quite some distance from home and happened to attend a small local fair. As I strolled about, amongst balloons and the jostling crowd, I looked up to see a young girl perched in the crotch of an old apple tree, a brown paper bag clutched in her hand. She seemed to have found complete solitude, unmindful of the people below as she opened the bag and quietly ate her lunch. Unnoticed, I made the small thumbnail sketch shown on the opposite page (upper left corner).

Later, back in my studio, I decided the subject was an interesting one to paint, but the information in the sketch was not enough to work with. Rather than return to the original scene I spent one morning driving around my area looking for a tree that would approximate the one in the sketch. Strangely enough, the one my wife suggested I look at was unbelievably similar, shown in the pencil study on the opposite page.

Next, I had a neighbor's daughter pose for the charcoal study shown in the lower right corner. The drawing is really a combination of direct observation of the model and my memory of the first girl in the tree. With the combined information I completed the painting shown on the next page. Since it was primarily the silhouette image that I was after, I chose the simplicity of watercolor as the medium.

I must say that I prefer traditional watercolor paints to acrylics when working on watercolor paper because I frequently scrub out an area to make an adjustment in the painting. In this case, for example, I had originally included the small curving branch as shown in the diagram on this page. Then I realized that the shape seemed unnatural and attracted undue attention. It looked like a big egg or a football between two limbs. So I scrubbed out part of the branch. You may still be able to faintly make out the rest of the branch in the reproduction on the next page. I had also been unhappy with the lower section of the tree trunk, so I scrubbed it out and repainted the entire area.

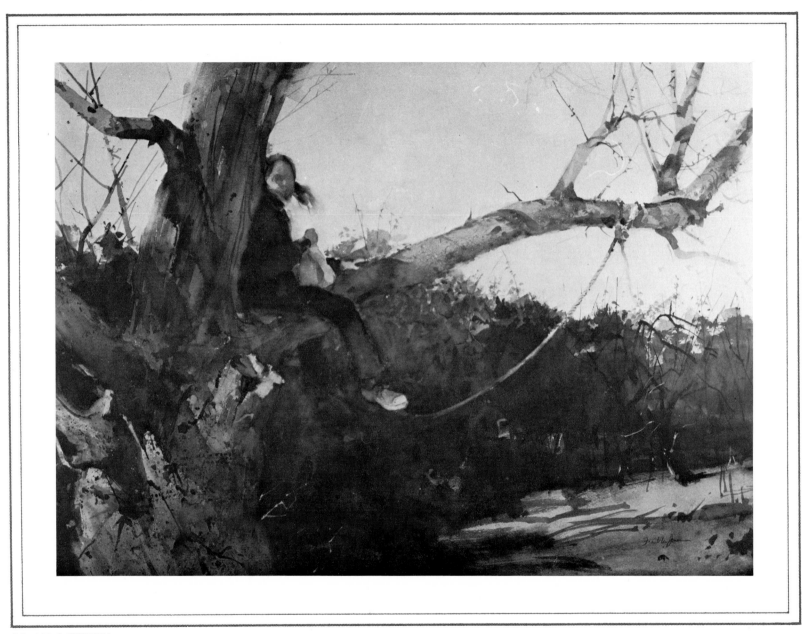

OF ALL I SURVEY
Watercolor, 23 x 32 inches

▷

Detail from watercolor and acrylic painting, DISTANT MOUNTAIN.

Below is a different situation, in which no figure was in the scene as I observed it.

Last fall my wife and I were hiking in Vermont with our friends, Pat and Frank Dupree, who own a farm up that way. In fact, the farm has been the source of many of my paintings. Anyway, we came out of the woods into a field that stretched away toward a distant range of hazy-blue mountains. It was so quiet I could hear the call of some crows as they crossed the landscape some half-mile distant. As I stood there wth my pack on my back, I imagined myself crossing the autumn brown fields on an endless journey of delightful escape from the everyday world. After making notes and studies of the landscape itself, I had Pat (she being the camera enthusiast) take a photograph of me in the pose I wanted, with the same lighting arrangement that I planned to use in the painting.

For the final painting, which was done in my studio, I used the photograph as a guide to pose again in front of a full-length mirror. The photograph itself was too dark and small to work from directly; otherwise, I would have used it. The reproduction below shows only a portion of the finished work. In this instance the painting was started with watercolor on illustration board; and then the figure, distant mountains and minor highlights in the field were further refined with acrylics.

In all of my paintings where I'm principally concerned with the landscape, I try to keep the figure subdued sufficiently in detail so it remains a part of the surroundings. In this painting the details were especially subdued to create the feeling that the viewer is looking toward the light at a back-lit form. The bright light area of the kettle hanging from the pack serves to catch our eye, making the figure the focal point of the painting. At the same time this strong contrast helps to bring the figure forward.

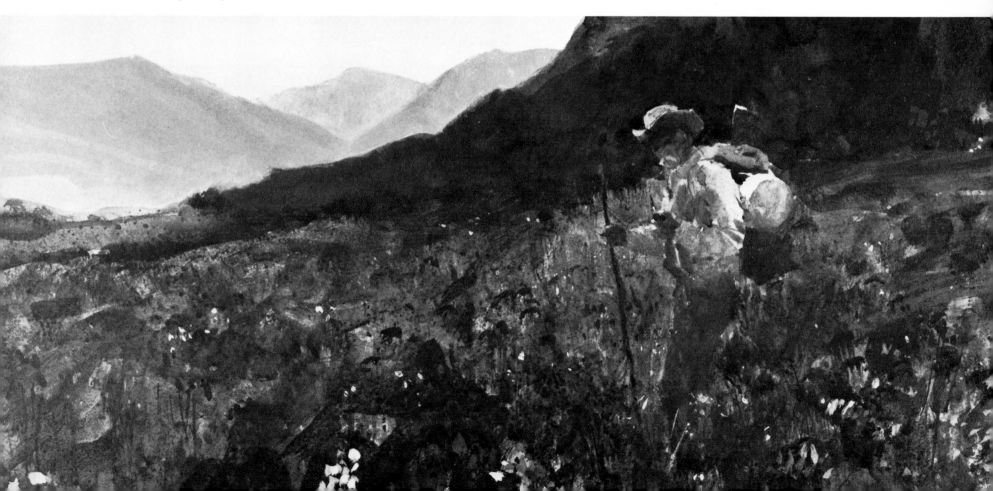

Now let's look at another figure problem, one more difficult than using myself as a model. This was an interior painting which involved traveling back and forth between the subject and my studio. This was a painting of the interior of a farm house in the restoration village of Sturbridge in Massachusetts. It was late November, the day was biting cold, and I was enjoying the warmth of the kitchen fireplace, the room filled with the tantalizing odor of stew and hot gingerbread. A lad who worked at the village came in to warm himself by the fire, and the cook give him a piece of the hot cake. The situation would make a delightful painting had I been able to set up my easel right there. But there was one draw-back: a constant stream of visitors slowly made their way through the small room. Tucked back in the far corner I made pencil studies on a small pad of paper. The young man obligingly posed for me, happy enough to spend some time inside away from the cold. "Smells like snow in the air," I commented. He looked at me in surprise. "You mean you can smell snow coming? I've never even seen it . . . this is my first time up North."

Back in the studio I set to work on the painting, developing the composition and laying in the underpainting. As I worked I recalled our conversation, so decided to include new falling snow out-side the window. Just the thing needed to strengthen the contrast around the head of the figure, and it would certainly contribute to the story I wanted to tell.

The first time I went back for more studies of the room itself, I found that they had decided to rearrange the furniture. Painting is a pleasure, but there are some moments of frustration, too. Well, I didn't change the painting, but it made my research more difficult. I made some further observations of the model and went back to the studio.

The third visit was more difficult, for I could not locate the young fellow. I presume he finally saw the snow and headed back South. Back at the studio I again used myself as a model for the final stages of the figure, simulating the lighting by sitting in front of a window and using the full-length mirror. The one thing that didn't change with each visit to the village was the smell of ginger-bread, fresh from the old Dutch oven.

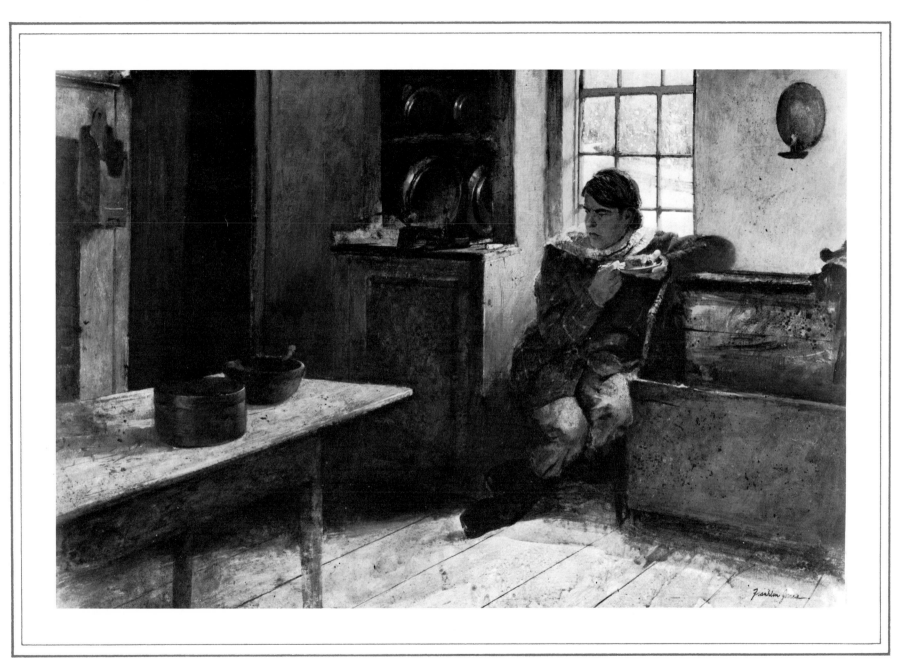

THE SMELL OF GINGER
Acrylic, 19½ x 29½ inches

Section 11

This and that

Anyone seriously interested in learning to paint should spend as much time as possible working directly from life, not from photographs.

Why, then, have I included information on the subject of the camera? Because some students are going to ignore that advice, feeling that it's much easier and more convenient than working from nature. Therefore I feel that if a person is going to use the camera as an aid to painting, he should do so wisely. Photographs should be taken as reference material, not as the subject for the painting. Paint from nature, draw from nature, observe from nature. When it's necessary to complete the painting in the studio, take photos to assist you in remembering those things you've observed. This is the way I use the camera. (I should point out that I worked only from life for the first fifteen years of my career.)

When I've completed my studies and observations, I take not one, but a number of photos of the subject from various angles and distances. I shoot close-ups of complicated construction that may be useful in refining the final painting. Since I prefer to use color slides, I intentionally vary the exposures so as not to be unduly influenced by the film's color.

I recall a student showing me a painting of a calf standing in the shade of a massive tree. When I asked why he'd painted the animal such a bright blue he proudly produced a color slide to show me how accurately he had matched the color. And he had. And the photograph was a perfectly acceptable image of a white calf standing in shadow. But on canvas this same color produced a blue calf as imaginative as a purple cow.

Too much reliance on the camera can prove disappointing in many instances. Once I started a painting of Mt. Equinox in Vermont and had hardly established the lay-in when I had to leave for some reason. So I decided to take a photograph and finish the painting at home. When the film was developed I could hardly believe it was the same subject. The small image in no way resembled my impression of the area. The photo showed the facts. I had been painting my personal impression derived from numerous hikes over and around those slopes. I went back to the scene and once again felt the personal relationship with the mountain and was able to complete the painting.

Slides provide me with color information only in the broadest sense. I much prefer to base the color on direct observation or my own feelings. For one thing, I work with relatively subdued intensities, for I'm usually more concerned with shapes and values. Color slides are generally too colorful. I prefer them to black and white prints, however, for reference purposes, because I get a greater sense of perspective or depth when viewing them in the studio.

I have a table viewer that allows me to see the slides on an eight inch screen. While working on the painting I intermittently look at the group of slides but don't actually paint from them. For a complicated piece of construction, I may draw while viewing the slide.

I mentioned that some people feel it's easier to work from photographs. This may well be true in terms of copying the images. But to reiterate . . . painting is not merely duplicating what you see. The results of working from nature will be more interesting and convincing because you have to construct and analyze and relate the objects. I will agree that for the beginning painter, or one who has worked only from photographs, nature may be somewhat bewildering in the first encounter. Minor lights and shadows, textures and other details are so obvious to the eye that you can't see the forest for the trees. They're not as visible when reduced to the scale of a photograph. But learning to see beyond those details, to determine what's important and what's superfluous, to take reality and enhance it through your own inventiveness and judgement . . . is all part of the pleasure that painting offers.

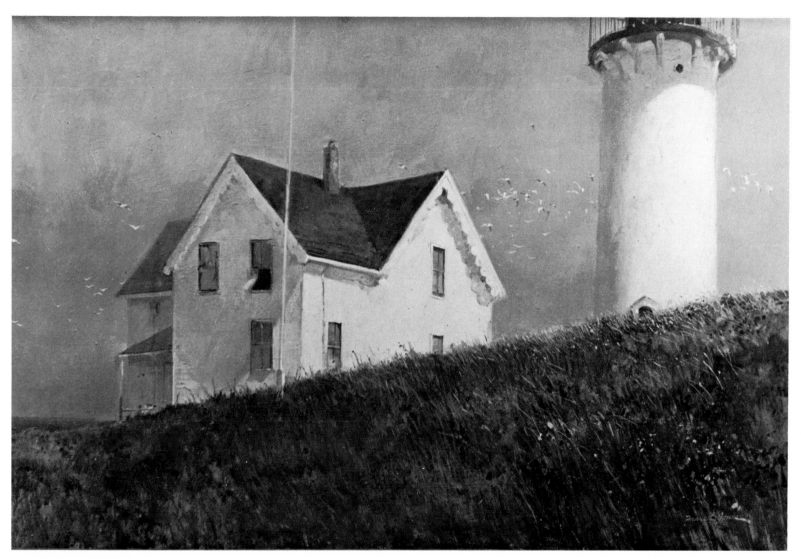

AFTERNOON BREEZE
Acrylic, 20 x 30 inches

GERANIUM
Oil, 24 x 30 inches
Owned by Mr. and Mrs. George McDonald

Having talked about the ways and means of using the three mediums, we should conclude our visit with some mention of the proper framing methods for each. The choice of the frame itself is up to the individual. Depending on the dimensions of the painting these may have to be custom built or they may be obtained in standard sizes such as 16" x 20", 18" x 24", 24" x 30", etc., usually at a lower cost than those made to order. However, I prefer to design the shape of the painting to fit my subject, so it may or may not fit a standard size frame.

The traditional method of protecting an oil painting is to give it a coat of varnish, but some painters don't bother, either because they don't like the glossy finish, or they just don't feel it's necessary. Varnish does provide a richness to the color and a uniform appearance to a painting that's partly shiny, partly dull. I prefer to apply the damar varnish with a brush, in an area free of dust. However, varnish should not be applied until the oil paint has dried completely. Oil paint dries very slowly and tends to contract as it dries. A coating of varnish (which dries quickly) applied over a fresh painting would eventually break apart, producing a pattern of cracks. Therefore, the average painting should not be varnished until it has dried for about six months. A thinly painted picture may be varnished sooner; a thick, impasto painting should wait longer. For protection of paintings from surface dust or grime, all oils should be varnished within a year.

The more fragile watercolor painting should be matted and framed behind glass, and backed by heavy cardboard. The mat serves as a border and also separates the painting from the glass to prevent contact with any condensation which might adversely affect the painting. I personally don't recommend non-glare glass, as it takes away from the richness of the colors.

An acrylic painting done on canvas or some rigid support such as Masonite need not be varnished if the final layers of paint were not thinned excessively with water. If the binding strength of the paint has been reduced or you're not certain about it, then I'd recommend a final coat of emulsion or acrylic varnish.

If the acrylic painting is done on paper in the manner of transparent watercolor, it would be best to frame it under glass, with a mat, in the same manner as a traditional watercolor.

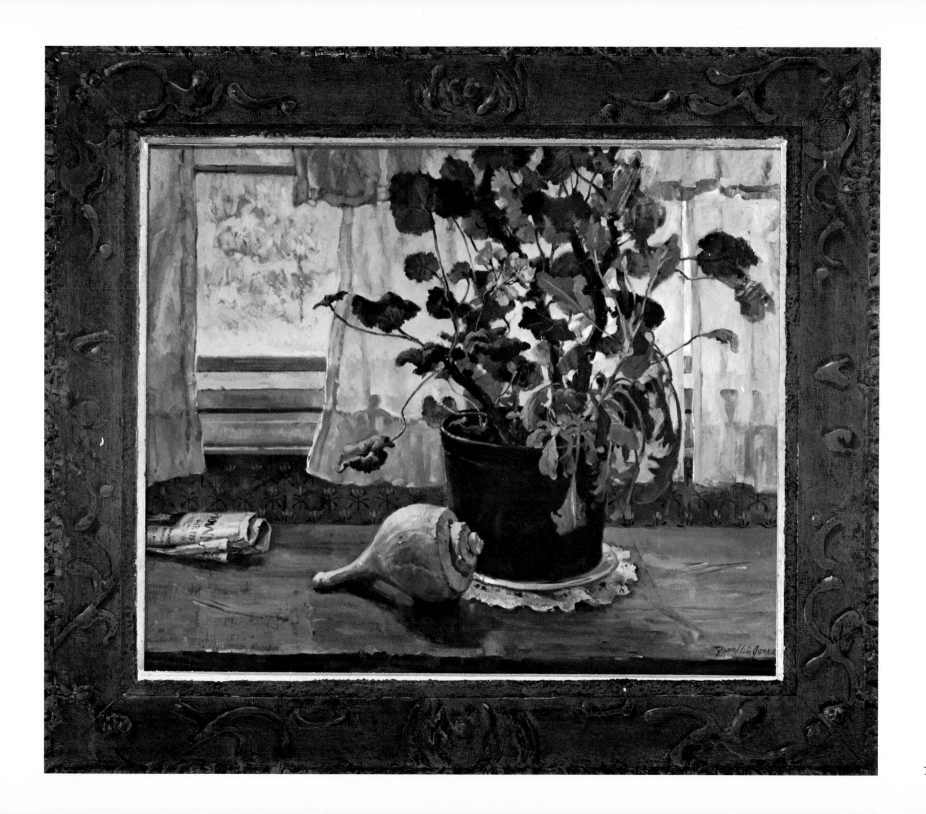

Unfortunately our visit has been all too brief for me. I thoroughly enjoy the opportunity to "talk shop" with pleasant company. Perhaps we'll have the chance to get together again, our painting gear slung over one arm, a tasty lunch in our packs. We'll walk together along the ocean's edge and down quiet country roads. We'll capture on paper and canvas those personal glimpses of nature that lie just beyond the vision of the layman — so we may bring them to him.

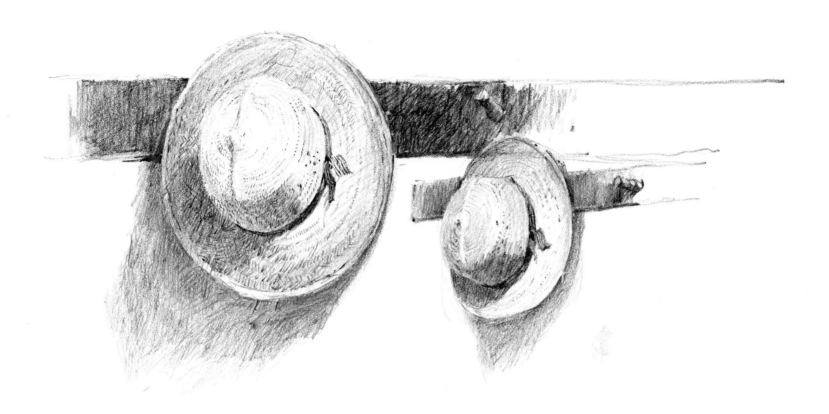